HOW TO DRAW
FANTASY ART

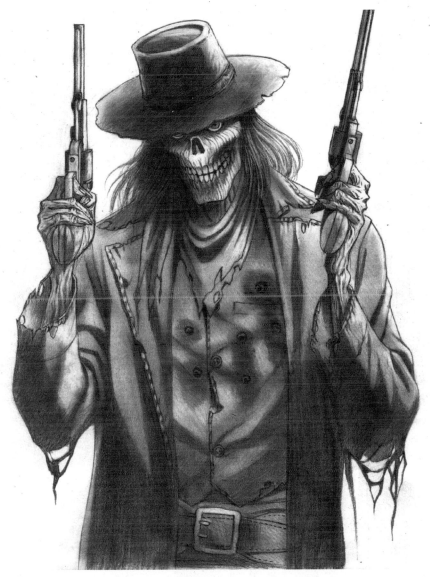

STEVE BEAUMONT

Credits

Thanks to the following artists' materials brands that appear in this book:
Copic® [Copic is a trademark of Too Corporation in Japan], Derwent,
Faber-Castell, Letraset, Staedtler, Winsor & Newton.

Picture credits: The Kobal Collection (Art Archive): 114 (Figure 6);
Shutterstock: 29, 53 (Figures 1–5, 59 (Figures 2 and 3), 62 (Figures 6–8),
68 (Figures 17 and 18), 75, 76, 84, 89 (Figures 3 and 4), 92, 106, 114
(Figure 5), 115, 116, 126.

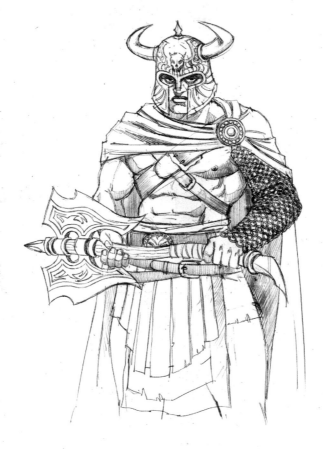

ARCTURUS

This edition published in 2012 by Arcturus Publishing Limited
26/27 Bickels Yard, 151–153 Bermondsey Street,
London SE1 3HA

Art Director: Peter Ridley
Designer: Mike Reynolds

ISBN: 978-1-84858-422-8
AD00193JEN

Printed in Singapore

CONTENTS

Introduction: Wild Imaginings Page 4
Materials and Techniques Page 8
Getting Started: The Basics of Figure Drawing Page 16

EXERCISES

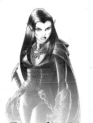
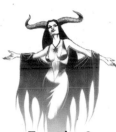
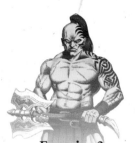
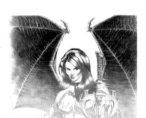
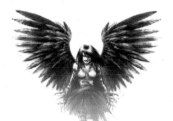
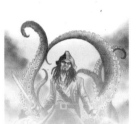
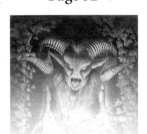
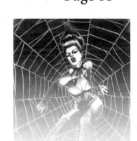
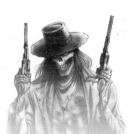
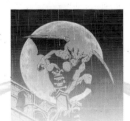

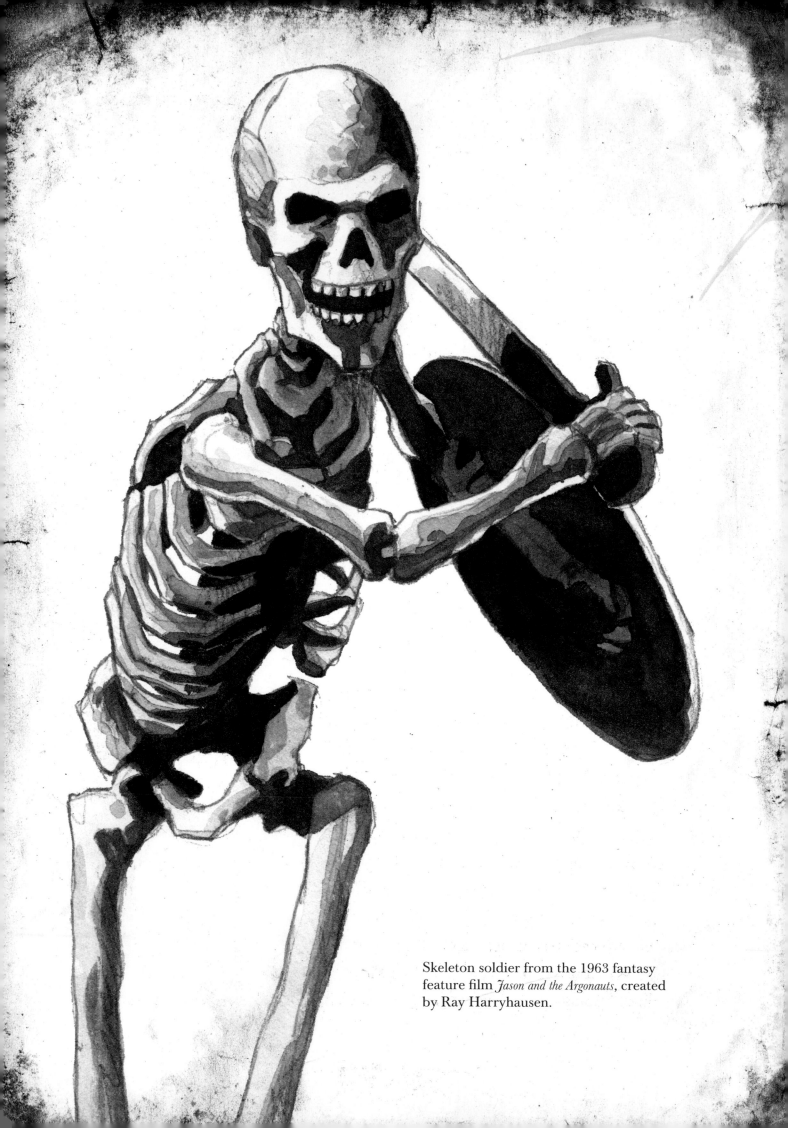

Skeleton soldier from the 1963 fantasy feature film *Jason and the Argonauts*, created by Ray Harryhausen.

WILD IMAGININGS

As a child, I liked nothing better than losing myself in a sci-fi or horror movie or a pile of superhero comics. My favourite films were the ones that featured creatures created by Ray Harryhausen and included *Jason and the Argonauts, One Million Years BC* and *Golden Voyage of Sinbad,* in which, for me, the animated characters rather than the actors played the starring roles.

These stop-motion model animation (dynamation as it became known) movies had a huge impact on me, as did the work of Jack Kirby, the legendary comic book artist, and Frank Frazetta, whose work I still regard today as the best in fantasy art. Indeed, I believe that had I not been impressed by Jack Kirby's art work and wanted to copy it, I may never have picked up a pencil and started to draw.

Unfortunately my passion for fantasy art, sci-fi and comics was not shared by the teachers at my school, who considered it to be a futile pursuit.

It was my dream to go to art college and learn to draw to a professional standard, but a series of events shattered those dreams and I never did get that opportunity. However, my love of fantasy art did not die and I continued to watch fantasy movies and read superhero comics, which inspired me to create my own fantasy art. I believe art college is a good place to develop your skills as an illustrator and education is paramount, but I do not think that it is the only path to success in illustration. My own experience has shown me

Drawn by Steve Beaumont, aged 6.

that determination, a love of drawing and continuous practice will get you there in the end. Indeed, the purpose of this book is to encourage others to develop their fantasy art drawing skills, whether they have been lucky enough to have had an education in art or not.

This book is an entry-level guide to fantasy art. For the most part all you will need is a decent set of pencils, an eraser and some good-quality paper, as most of the exercises in this volume were produced with exactly those materials. All the exercises can be executed with varying levels of success depending on how much work you are prepared to put in. It all comes down to practice and attention to detail, which in turn comes from being observant and willing to learn. I wasn't born being able to draw the way I can now (as you can see from my childhood drawing on page 5); my skills developed over time and required practice, imagination and a lot of resolve. I am now a freelance artist producing illustrations, concept art and storyboards for the film, television and video game industries, and I have illustrated a number of graphic novels. The tutorials in this book are based on fantasy art classes that I teach at Swarthmore Learning Centre, Leeds (UK).

Although the purpose of this book is for you to have fun discovering the possibilities of fantasy art, it may also awaken talents that could lead to something more. Whatever the future holds, I hope that the book will inspire you to pick up a pencil and create some wild imaginings too.

Steve Beaumont

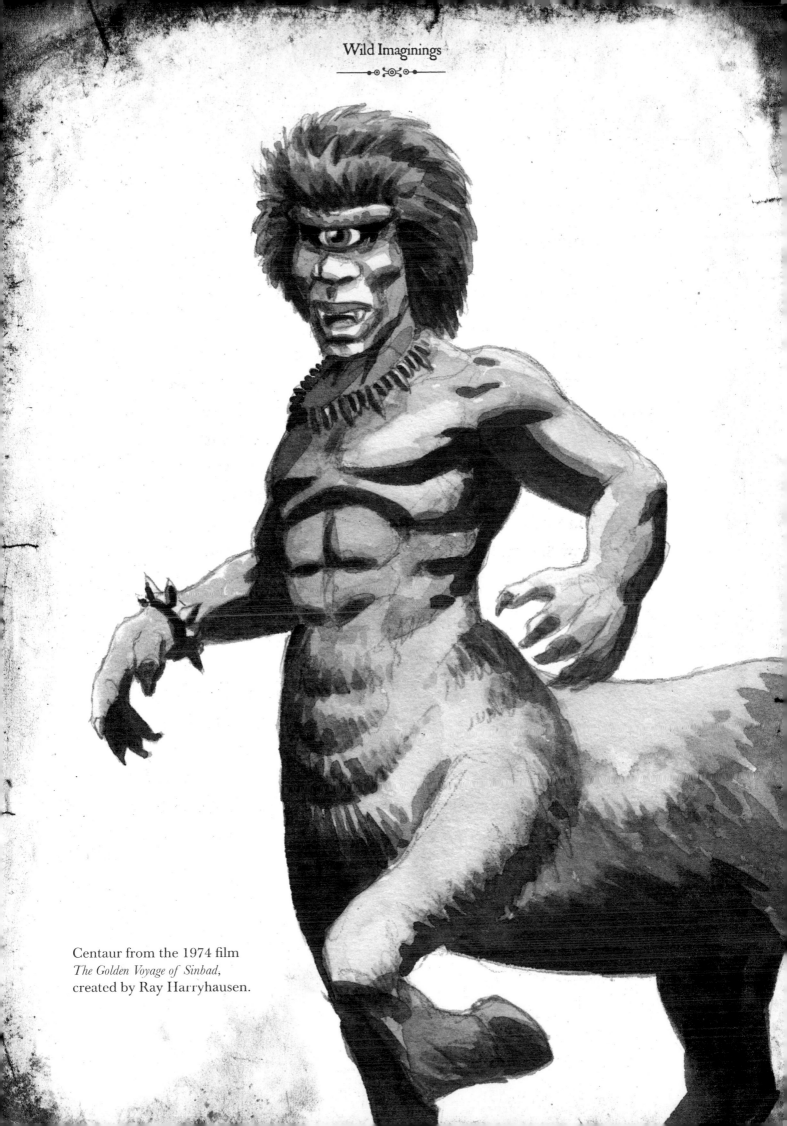

Centaur from the 1974 film
The Golden Voyage of Sinbad,
created by Ray Harryhausen.

Materials and Techniques

Artists use a wide variety of materials. Some choose to work in watercolours, some prefer oils or acrylics, while others decide to use inks, pencils or pastels. I suggest that you test all these mediums because only by trying them yourself will you find the right one for you.

To get started, you only really need a decent set of pencils and some high-quality drawing paper, but I will recommend some other basics that you may enjoy using. It's best not to go for the cheapest materials as you often get what you pay for in terms of quality.

The items I have presented here are by no means the only brands available, but they are the ones that I use on a regular basis and, indeed, that I used to create the drawings contained within this book. All of the recommended materials are available to buy on the Internet, if you do not have an art store near where you live. Good sites in the UK, where I buy my materials, include http://www.cultpens.com/ and http://www.artifolk.co.uk.

In this section I will also look at how to use these materials, showing some useful techniques for the exercises in the book.

PENCILS, ERASERS, BLENDERS AND PAPER

These are the tools that form the foundation of all the fantasy art you are going to create, whether you are devising a drawing to be inked, coloured or to be rendered purely in graphite. Most of the exercises in this book were achieved using a basic pencil, an eraser and some good-quality paper.

PENCILS

There is a huge range of pencils available, and it is worth trying out a few to see which you prefer. These are a few of the most common ones:

Pentel Clutch pencil: This is available in a number of lead weights and thicknesses and it uses lead refills, meaning there is no need to sharpen it. This is great technical pen for fine detail.

Wolff's Carbon: Provides the depth of tone of charcoal with the smooth finish of graphite.

Derwent Water-soluble Graphite: A pencil-shaped stick of pure water-soluble graphite, which can be used as a conventional pencil, broken into chunks to create broad sweeping strokes or for subtle washes.

Faber-Castell Pitt Graphite: This is a very high-quality pure graphite sketching stick that gives excellent tone. It is also available as a crayon stick.

Derwent Sketching Pencil: This reliable pencil is available in the usual range of H–HB–B leads.

Rexel Cumberland Derwent Graphic: A good-quality, low-priced pencil that gives pleasing results on most papers.

Staedtler: This is a very reliable budget-range pencil that gives great results.

I tend to use Staedtler HB pencils for most workings out and even some finished art. Derwent are another preferred choice.

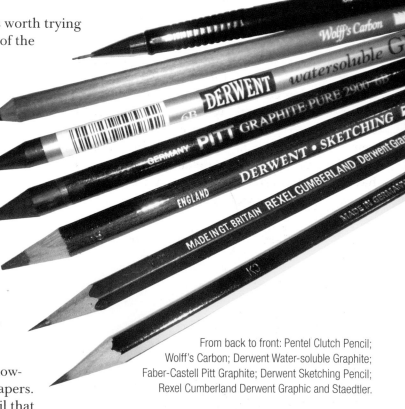

From back to front: Pentel Clutch Pencil; Wolff's Carbon; Derwent Water-soluble Graphite; Faber-Castell Pitt Graphite; Derwent Sketching Pencil; Rexel Cumberland Derwent Graphic and Staedtler.

PENCIL WEIGHTS

Here is a list of pencil weights and their qualities:
• H leads are hard and create a lighter mark on the paper. The range consists of H–9H, with 9H being the hardest.
• HB pencils are a good mid-range pencil, giving a wide variety of tone between the H and B leads.
• B leads are softer and leave a lot of lead on the paper, which is easily smudged. The range consists of B–9B, with 9B being the softest.

ERASERS

There are lots of erasers on the market, but only a select few good products. Don't go for the cheapest as you will often find these are inferior. I tend to use Winsor & Newton putty rubbers (Figure 1), Staedtler plastic erasers (Figure 2), and a Derwent battery-operated eraser (Figure 3). The small eraser on the end of a Staedtler pencil is also useful for creating detailed highlights.

Figure 2

Figure 1

Figure 3

BLENDERS

A lot of pencil work involves blending pencil lead to give a smooth area of tone or to create clouds of smoke or other effects. To create these I use tissue paper wrapped around my index finger or a blending stump (Figure 4). Tissue paper can give a softer, gentler blend over a larger surface. Stumps are very good for smaller areas and detail work, although I have seen many artists use a stump for large areas too.

Figure 4

PAPER

Most of the drawings in this book were produced on 180gsm acid-free cartridge paper. Generally, choose a good-quality cartridge paper of a reasonably sturdy weight, as this will prevent your artwork from easily being creased and bent. There are many brands of paper on the market, including Winsor & Newton, Derwent, Daler, Canson and Snowdon, all of which produce good-quality cartridge paper as well as lower-quality student pads for practising on.

Bristol board is mainly used for inking as it has a very smooth surface that is ideal for extra-crisp line work. I have not used Bristol board for any of the exercises in this book. In most cases I have inked directly on to cartridge paper or, in the case of the projects that use marker pens, layout paper, although many artists prefer to use 160gsm photocopying paper as it produces good results when using marker pens.

Pencil techniques

Shading

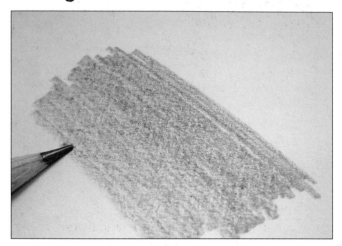

Position the pencil so that the flat edge rubs across the paper.

This gives you a wide coverage and is useful when shading a large area.

Blending 1

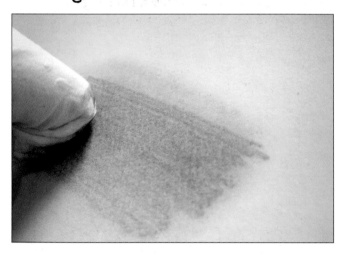

Wrap some tissue paper or soft cloth around your finger and run it across a shaded area so that the pencil strokes begin to blend together.

This action will give a smoother surface to your pencil work and is especially good for large areas.

Blending 2

A blending stump is another good tool for blending pencil work. Hold the stump as you would a pencil and apply a little pressure.

This technique gives you a lot of control over the blending and is useful for detailed and smaller areas.

Highlights

For this technique, use either a rounded edge of a Staedtler plastic eraser or a putty rubber to create lighter areas. You need to assess from which angle the light is coming when applying highlights and ensure you are consistent when you position them. Highlights can also be used to mimic the way flames flicker and smoke swirls if you drag the eraser across the pencil work to create sinuous shapes.

Creating cloud effects

You can use a combination of blending and erasing to create cloud effects. First, shade the area and blend it with tissue paper, then give the edge of the clouds definition by chiselling away with an eraser. Finally, go over the image again with tissue paper to soften the edges.

POINTER NOTES

This image (Figure 5) was drawn using an HB2 and an II pencil. The clouds were created using the blending technique. The highlights were made with a finely chiselled eraser and the fine highlights on the barbed wire were created by painting with gouache and an '0' round sable Winsor & Newton watercolour brush. You can follow the whole exercise on pages 68–73.

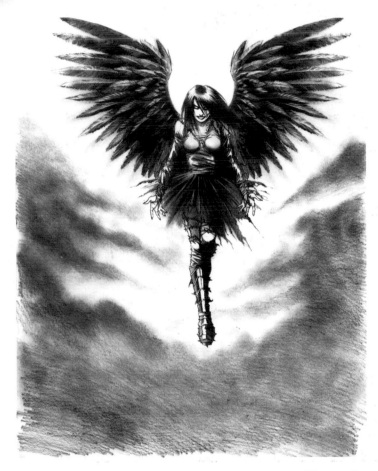

Figure 5

INKING

Inking requires a lot more concentration than mark-making with a pencil, as every pen/brush stroke is permanent and can only be corrected by painting in white over the top or, if you are using Bristol board, by scraping away the top surface with a surgical blade.

The powerful impact that black ink has on a drawing cannot be denied. Occasionally I use a brush for inking a drawing, but about half of my work is inked using Faber-Castell Pitt Artist Pens and Copic Multiliner pens. Both brands use waterproof Indian ink and give very pleasing results.

INK PENS

Faber-Castell Pitt Artist pens and Copic Multiliners are the brands I tend to use for inking and, although I do try out other brands and experiment with other tools, these are the pens that I feel most comfortable working with. They were also used to create the inked drawings in this book. Of course, you do not have to go by my recommendations; I suggest that you try various brands and types of tools to find the one that is right for you.

Faber-Castell Pitt Artist pens come in a variety of nib thicknesses (Figure 1, Figure 2 and Figure 3), indicated by the letter or letters on the side: XS = Extra superfine, S = Superfine, F = Fine, M = Medium and B = Brush. Faber-Castell also produce a Big Brush pen that carries their heaviest nib, which is a bit like using a No. 8 brush. My personal favourite is the B nib.

The Copic Multiliner (Figure 4) is a more technical pen than the Faber-Castell and, unlike the Faber-Castell pen, you can refill it with ink cartridges and also replace the nibs. These pens are available in a number of nib thicknesses, ranging from 0.03–0.7 to brush. Another benefit of the Multiliner is that your line work will not smudge or smear when coloured using Copic Colour Markers or watercolours.

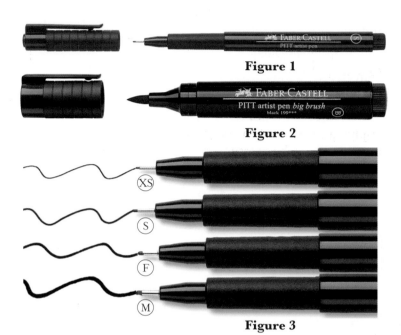

Figure 1

Figure 2

Figure 3

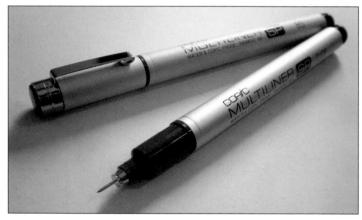

Figure 4

Figure 5

WATERCOLOUR BRUSHES

Watercolour brushes (Figure 5) are also great for inking, although inking with a brush is not as easy as using a pen and takes a lot more practice. The beauty of using brushes for inking, however, is that they come in a wide variety of sizes and, in the case of the much larger brushes, enable you to quickly cover larger areas with black.

Techniques

Varying the thickness of a line

Brush nibs and brushes are very versatile as they offer a variable line thickness that is determined by the amount of pressure you apply to the paper. The harder you press, the thicker the line. Fine nibs generally give a consistent thin line, which you can thicken by adding a second layer.

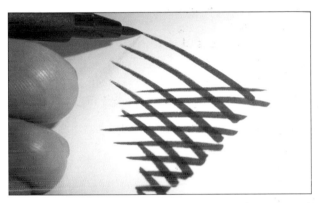

Hatching

Hatching is a method of building up shading using parallel lines. You can create tapering lines by applying pressure at the beginning of the stroke and then reducing the pressure gradually, as shown here.

Cross-hatching

Having created an area of hatching, you can create cross-hatching by repeating the technique at right angles over the first set of lines. This method is used to add texture or shading.

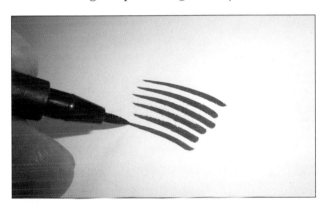

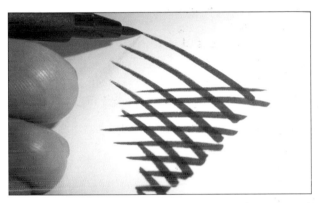

POINTER NOTES

The image in Figure 6 was inked using a Faber-Castell Pitt Artist Superfine Pen and a Brush Pen.

This picture (Figure 7) was inked using a brush pen.

This image (Figure 8) was inked using a superfine pen for the hatching and line work and a brush pen for the solid areas.

Figure 6

Figure 7

Figure 8

MARKER PENS

I use marker pens for quite a lot of my colouring as the hues are vibrant and can be manipulated by using a blender fluid. There are a number of brands of marker pen available, but by far the most popular are the Letraset Tria and the Copic Marker, of which the latter is my preference.

THREE-NIB PENS

The Letraset marker pen (Figure 1) is considered the best three-nib pen. All nibs are replaceable and the markers are also refillable.

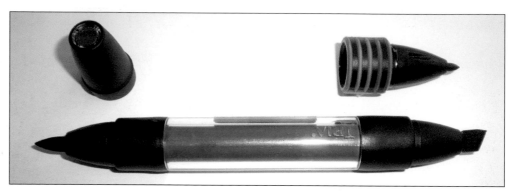

Figure 1

TWO-NIB PENS

Although these marker pens only have two nibs, each type is available with a range of three nib choices: the Classic marker (Figure 2), which features a wide chisel and a fine nib; the Sketch (Figure 3), which has a small chisel and a brush nib; and the Ciao (Figure 4), which has a super brush nib and a medium-broad chisel nib. All Copic markers are refillable with bottles of Copic ink and all nibs are replaceable.

Figure 2

Figure 3

Figure 4

Techniques

Using different nibs to vary line thickness

The Classic Copic marker nib range enables an artist to easily create lines of varying thickness. The top line was created with the chisel nib and the lines below were created with the fine nib.

Covering a large area with tone

Drawing slightly overlapping lines with a chisel nib results in a neat area of flat tone and is a quick way to colour a large area.

The effect of blender fluid

This image shows how ink in a coloured area reacts to Copic blender fluid that has been applied randomly. Ink disperses outwards through the paper away from the area where the blender fluid is densest, creating a region of paler colour with a bounding ring of darker ink. Blender fluid is also good for creating graduated tone when carefully applied using a chisel nib of a blender marker (colourless blender 0). Blender ink can also be applied using either cotton swabs or cotton buds.

Achieving different effects with the Sketch and Ciao pens

This image shows the various types of line that are achievable with the Sketch and Ciao marker pens. The top line was created with the chisel nib and the thinner lines were created with the brush nib.

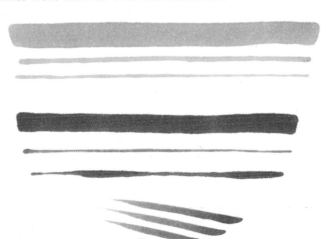

POINTER NOTES

This image (Figure 5) was coloured using Copic markers. There is a breakdown of the application on pages 48–51, so you can re-create the image yourself.

Figure 5

THE BASICS OF FIGURE DRAWING

The job of a fantasy artist is to make the unreal seem real and the unbelievable, believable. Almost all fantasy art contains human or human-like figures, whether these are 'normal' or distorted beings or some kind of creature that walks on two legs. They can all be drawn with more conviction if the artist is familiar with basic anatomy.

BASIC ANATOMY

A study of the human skeleton is essential, but it is not necessary to know the names of every single bone. Nor do you have to draw a full skeleton every time you sketch a figure; by studying the structure you can simplify it and break it down into some basic shapes. The key is to get the proportions correct.

The image on the left (Figure 1) shows a human skeleton, and the image on the right (Figure 2) shows how this can be broken down into a more manageable frame, which can then be used as the basis of a figure. At this stage, the limbs can be represented by simple stick lines and the rib cage and hips as basic oval shapes.

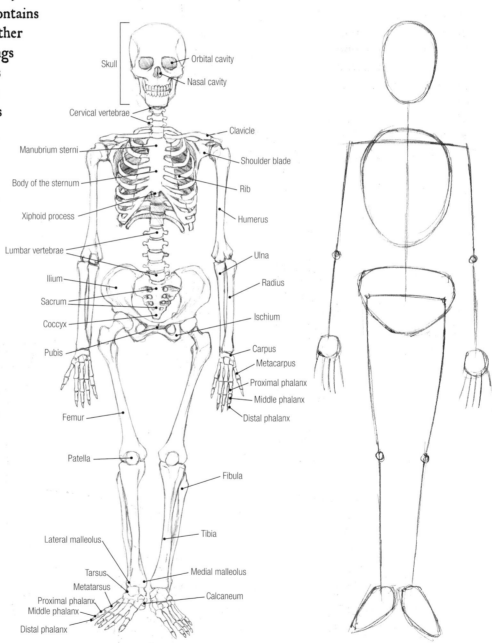

Skull
Orbital cavity
Nasal cavity
Cervical vertebrae
Clavicle
Manubrium sterni
Shoulder blade
Body of the sternum
Rib
Xiphoid process
Humerus
Lumbar vertebrae
Ulna
Ilium
Radius
Sacrum
Coccyx
Ischium
Pubis
Carpus
Metacarpus
Proximal phalanx
Middle phalanx
Distal phalanx
Femur
Patella
Fibula
Lateral malleolus
Tibia
Medial malleolus
Tarsus
Metatarsus
Calcaneum
Proximal phalanx
Middle phalanx
Distal phalanx

Figure 1

Figure 2

FIGURES IN ACTION

Once you are familiar with the skeleton, try drawing some rough sketches of stick figures in action. If you are drawing someone throwing a punch or swinging a sword, try to imagine the action and the direction of movement, and where the body weight is distributed. For instance, if the figure is throwing a punch it is more than likely that all the body weight will be supported by the leg that is farthest forward rather than by the rear leg.

You also need to consider the flow of movement and action. This flow can be simplified by a single stroke of a pen. This is evident when you look at the images of the upright figure with the staff in its left hand (below); one is annotated with arrows that indicate the direction of the twists and bends of the body, while in the alternative image the line of the pose has been simplified to a brush stroke.

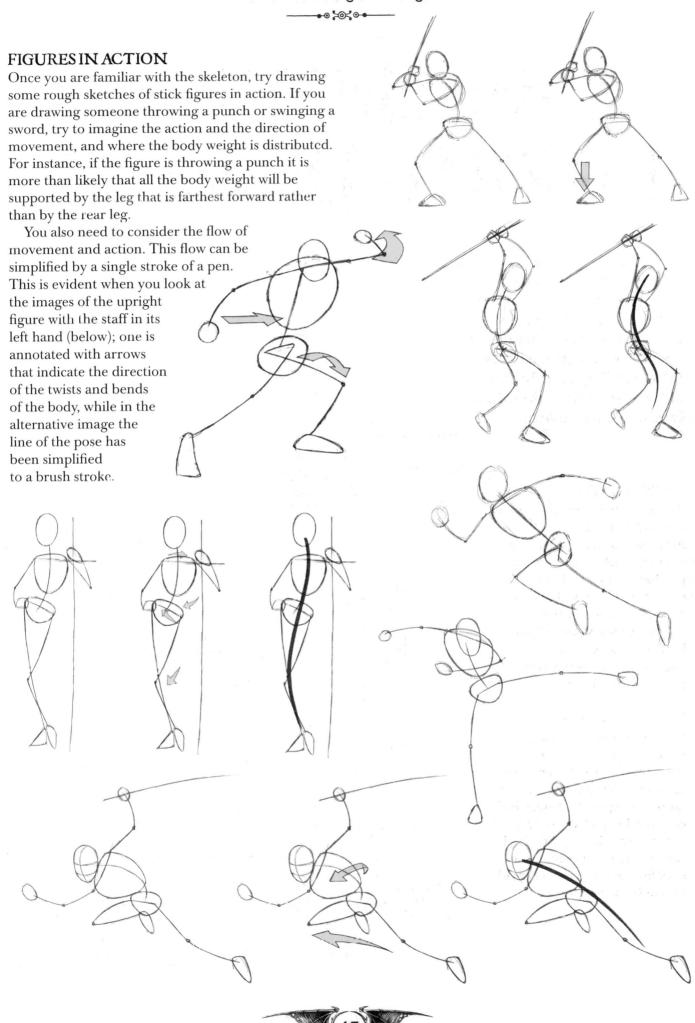

The next stage is to develop the skeletal frame into a more fully formed figure. One of the weaknesses I have noticed in the early stages of many students' work is the inability to gauge the proportions of anatomy correctly. Sometimes the head is too big or too small in proportion to the body, or perhaps the legs are too short or too long. One of the tried-and-tested ways of gauging proportions is to use the head as a unit of measurement. Generally, the body height of the average male is seven and a half heads tall. In fantasy art, however, it is common to exaggerate features, and male figures are often scaled up so their bodies measure eight and three-quarter heads tall. This results in a more athletic, heroic figure than is the norm in the real world.

Figure 1 shows a male with a body that is eight and three-quarter heads tall. The female in Figure 2 is given the same body height proportions, but notice the obvious differences between the two forms. The female's hips are much wider than those of the male in relation to the width of the shoulders. The feminine form is not as muscular – notice the width of the female arms compared to those of the male.

Figure 1 **Figure 2**

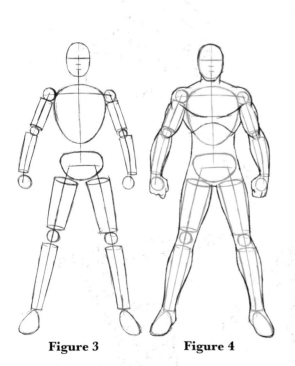

Figure 3 **Figure 4**

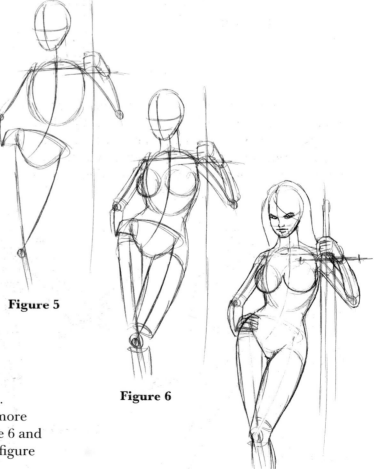

Figure 5

Figure 6

Figure 7

Figure 3 and Figure 4 show how a figure can be constructed using simple circles, ovals and cylinders. This method will enable you to successfully draw a more balanced figure from various angles. Figure 5, Figure 6 and Figure 7 show the stages of development from stick figure to fully formed figure.

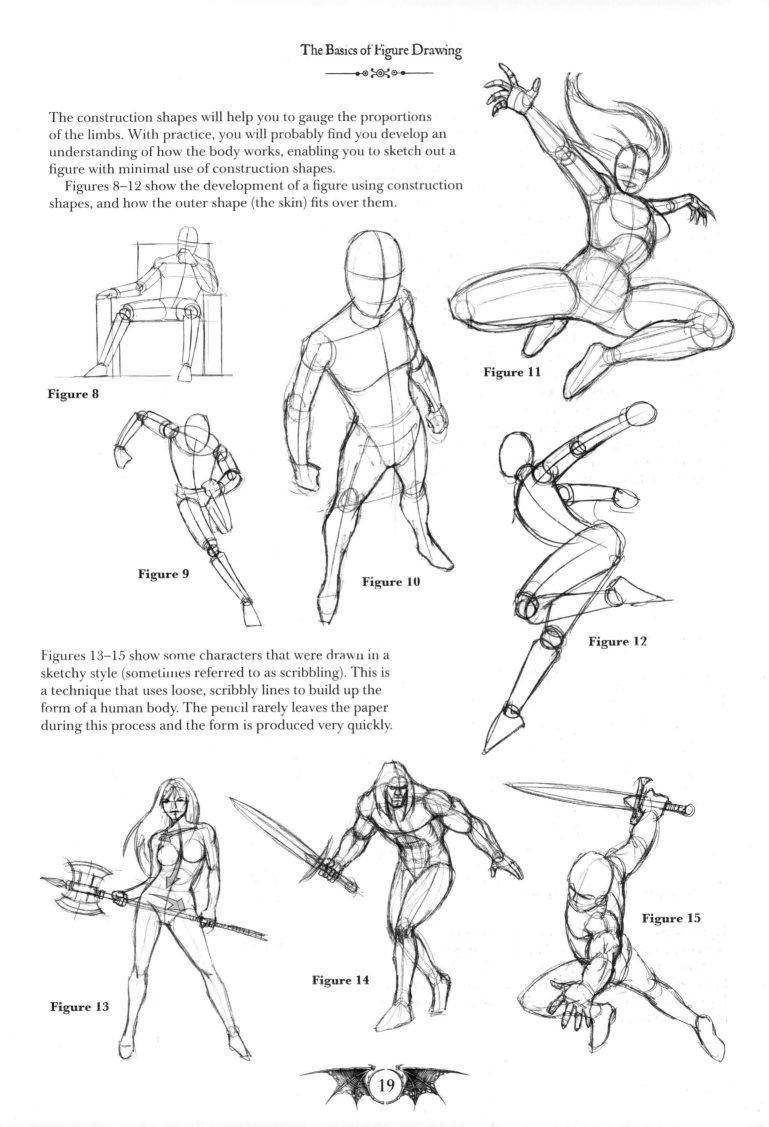

The construction shapes will help you to gauge the proportions of the limbs. With practice, you will probably find you develop an understanding of how the body works, enabling you to sketch out a figure with minimal use of construction shapes.

Figures 8–12 show the development of a figure using construction shapes, and how the outer shape (the skin) fits over them.

Figure 8

Figure 9

Figure 10

Figure 11

Figure 12

Figures 13–15 show some characters that were drawn in a sketchy style (sometimes referred to as scribbling). This is a technique that uses loose, scribbly lines to build up the form of a human body. The pencil rarely leaves the paper during this process and the form is produced very quickly.

Figure 13

Figure 14

Figure 15

DRAWING THE HEAD

Learning to draw a human head is critical as most pieces of fantasy art contain a human figure or a variation of one. The proportions of a human skull will usually fit within a square. By dividing this square into four equal sections you can determine the position of the eye line (which is situated about halfway between the top of the head and the chin) and the centre line (the vertical mid-line). These two lines will help you to correctly place the features of the face.

Figure 1 shows the head in profile. Note that the end of the nose sits roughly halfway between the centre line/eyes and the chin, and the top of the visible ear is aligned with the eye.

Figure 2 shows you how to plot the face when viewing it from the front. When drawing the eyes, divide the head across its width into five equal spaces. The eyes will sit in the second and fourth spaces. Of course, in reality the human face varies tremendously and can be many shapes and sizes, but applying these guidelines to whatever shape head you are drawing should help you create a balanced face.

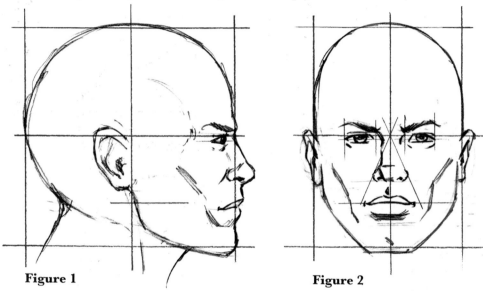

Figure 1

Figure 2

Another popular technique for drawing a head is to use a ball and a cube shape. Figure 3 shows the head constructed around these forms. The same principle can be applied whatever the angle of the head, whether shown at a three-quarter view (Figure 4) or a lowered three-quarter view (Figure 5).

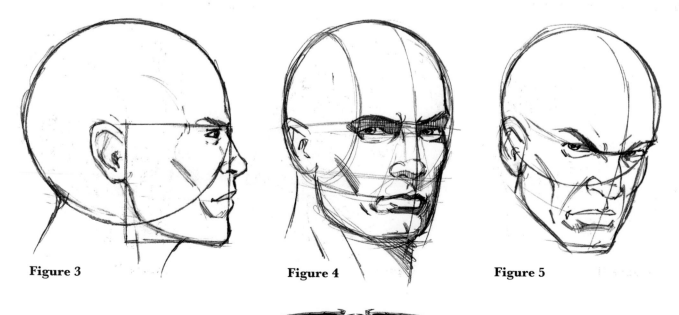

Figure 3

Figure 4

Figure 5

Here we have the female face. Figure 6 shows a round, young-looking face, while in Figure 7 you can see that by using a narrower grid to produce a thinner face the figure appears slightly older. Notice the shape of the eyes, which are larger and rounder (although essentially still oval) than those of a male, and the shape and thickness of the eyebrows. Using slightly bigger eyes on a female character will often make her appear more attractive. Also notice the shape of the female chin in Figure 8, which is narrower and more refined than that of a male, who would be likely to have a square jaw and flatter chin.

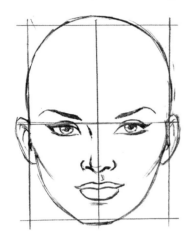

Figure 6

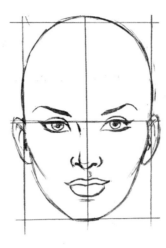

Figure 7

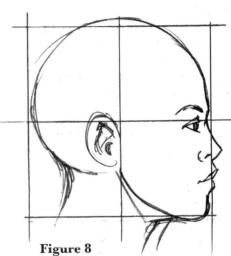

Figure 8

As with the male head, I have simplified the construction of the face and head to a ball and a cube shape (Figure 9). Have fun drawing the head at different angles (Figures 10–12). It may help to study your own head in the mirror at different angles, noticing what is visible and what is not when the head is tilted back, or turned three-quarters to the left or right, or tilted down slightly. You can learn a lot from studying your own face in the mirror, especially when trying to capture expressions.

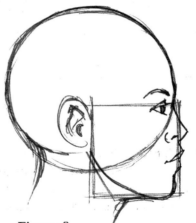

Figure 9

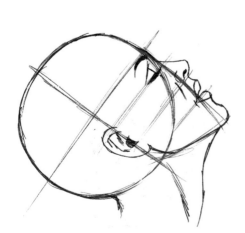

Figure 10

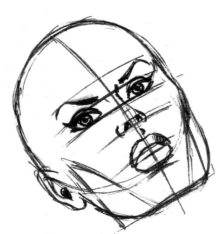

Figure 11

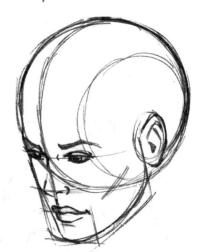

Figure 12

HANDS

I decided to devote a page to drawing the human hand as it is a complex part of the human anatomy, capable of forming a wide variety of shapes and positions. Most beginners struggle more with drawing this part of the body than any other. Because of the number of bones (14 bones for the digits of one hand alone!) and the complexity of the anatomical details you should not expect to be an expert at drawing hands by the end of the page; achieving this will take a lot of practice, but it is worth the effort.

When I attempt to draw something new, I often break the object into simple shapes, and this technique can be applied to drawing hands. Figure 1 shows the palm as a square and each of the fingers as three cylinders, joined to the hand by a sphere. The thumb is made up of two cylinders and a triangle, with a sphere to represent the joint.

Once the basic shapes are in place, the drawing can be fleshed out. Figure 2 shows the skin loosely sketched around the outside of the shapes, forming the main outline of the hand. Figure 3 shows how the hand looks as the details such as the fingernails and joints are defined.

Figure 1

Figure 2

Figure 3

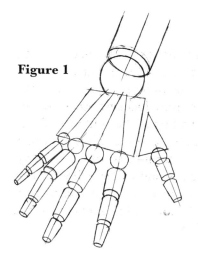

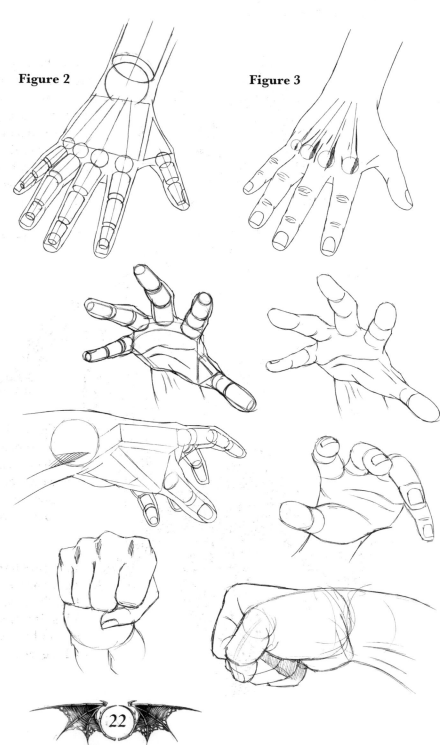

Use the progression from simple shapes to finished hand shown above to help you practise drawing hands and understand how they work. Consider all the different actions the hand can perform, such as grabbing, punching, pointing, making a claw shape, finger clicking and so on, and practise drawing them repeatedly. The sketches shown here may help you work out how to draw some of the more common or difficult movements, but you should also study your own hands and try to replicate what you see. Start with simple actions first and then build up to more difficult ones as you become more confident.

LIGHTING

Lighting plays a very important role in fantasy art, as it gives drawings atmosphere as well as visual and emotional impact. The position of the light source or sources will affect various elements of the image, such as the position of shadows and highlights.

One of the simplest ways to practise drawing light and shadows is using a sphere. Study the ball in Figure 1. Notice that the light is coming from directly above, highlighting the upper surface of the ball and creating a darker shaded area on the underside, as well as casting a shadow on the surface on which the ball is positioned. This is because when light is shone on a three-dimensional object it results in two types of shadow: form shadow (a shaded area on the object itself) and cast shadow (a shadow on a surface external to the object).

Figure 2 and Figure 3 show how the angle of the light source will affect the form shadow and the cast shadow.

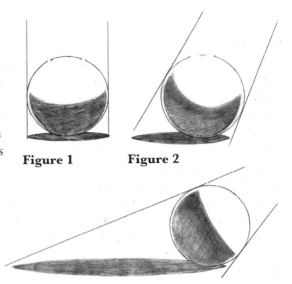

Figure 1 **Figure 2**

Figure 3

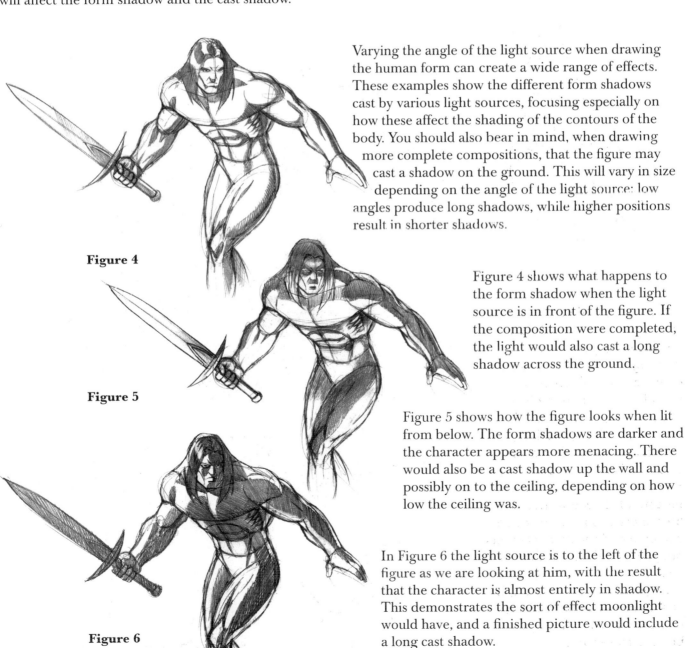

Varying the angle of the light source when drawing the human form can create a wide range of effects. These examples show the different form shadows cast by various light sources, focusing especially on how these affect the shading of the contours of the body. You should also bear in mind, when drawing more complete compositions, that the figure may cast a shadow on the ground. This will vary in size depending on the angle of the light source: low angles produce long shadows, while higher positions result in shorter shadows.

Figure 4

Figure 4 shows what happens to the form shadow when the light source is in front of the figure. If the composition were completed, the light would also cast a long shadow across the ground.

Figure 5

Figure 5 shows how the figure looks when lit from below. The form shadows are darker and the character appears more menacing. There would also be a cast shadow up the wall and possibly on to the ceiling, depending on how low the ceiling was.

Figure 6

In Figure 6 the light source is to the left of the figure as we are looking at him, with the result that the character is almost entirely in shadow. This demonstrates the sort of effect moonlight would have, and a finished picture would include a long cast shadow.

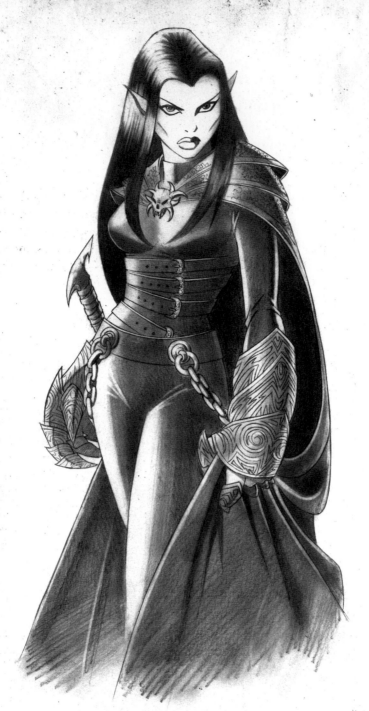

ELF PRINCESS

(Beginner's Exercise)

This first exercise is a good way to build up your confidence in figure drawing before tackling the more complex characters in this book. The main point of focus here is achieving the correct stance, as the attitude of the figure is conveyed through the pose. Drawing the character will also give you a chance to tackle clothing, armour and accessories, all of which are part of character design.

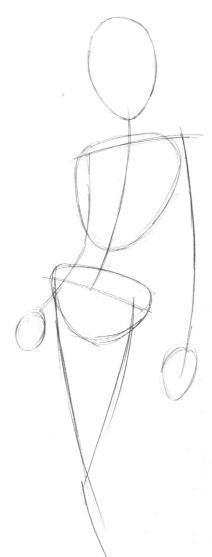

STEP 1

Begin by drawing a skeleton frame, using the techniques outlined on pages 16–17 and referring to this image as a guide. It is important to get the stance right before moving on to the next stage. If the pose is not balanced, all the shading and armour in the world will not disguise the fact that the figure's pose is weak.

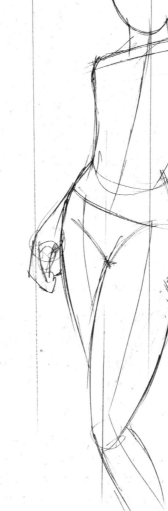

STEP 2

Once the skeletal figure has been drawn with the correct stance, flesh out the outer shape of the body and check the stance again, as it is easy to start over at this stage if you find it is unbalanced. The red arrows in Figure 1 clearly show the various angles of the pose. Notice that the figure is putting her body weight on her right leg (her left as we are looking at her), which is causing her hip to tilt and her left leg to bend. Her shoulders are also affected by the position of her legs – her right shoulder is lower than her left. The angle of the head is also important – notice that it turns towards us, adding another twist to the spine.

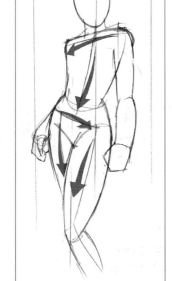

Figure 1

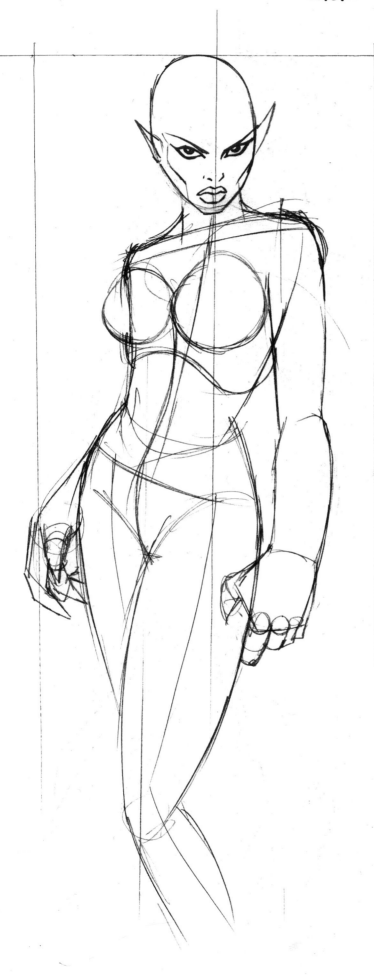

STEP 3

Once the pose has been established and you are happy with the balance of it, the rest of the body can be fleshed out. The breasts rest on the ribcage area and for now can be round or slightly oval. When drawing the face, keep the features simple. Try not to overwork it by adding too many lines. Notice I have not drawn the entire line for the nose, merely implying its position by carefully placing nostrils in the correct place. Because the head is tilting downwards, her eyes are looking slightly up through her eyebrows (Figures 2 and 3). Once you are happy with the face, you can carefully erase the guidelines (Figure 4).

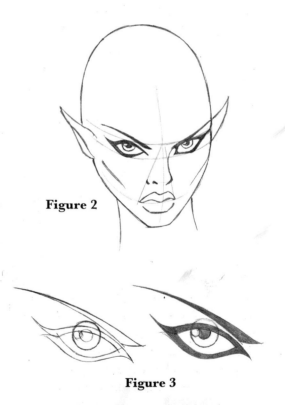

Figure 2

Figure 3

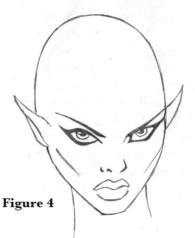

Figure 4

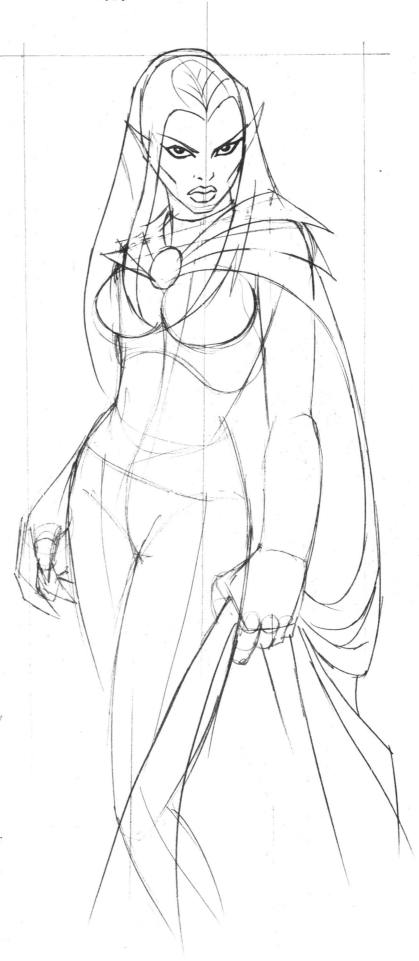

STEP 4

Now you can add details such as the hair and cape. Keep the shapes simple when drawing the hair. Go for curves that are aesthetically pleasing and try not to make things unnecessarily complicated. The same applies to the cape that hangs from her shoulders. When it comes to drawing clothing, a good point of reference is to look in the mirror and observe how garments fit and hang from your own body. For the cape, you could throw a sheet or blanket over your shoulders to see how it hangs down.

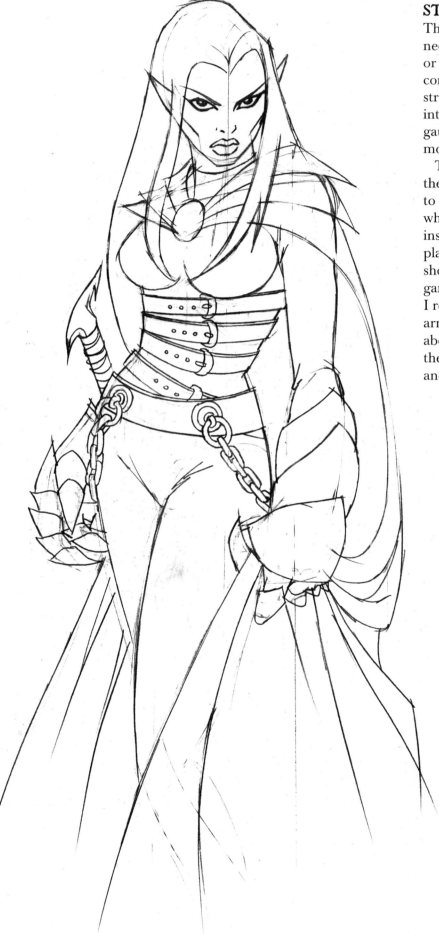

STEP 5

The clothing worn by the character now needs to be drawn. I chose a leather or rubber bodysuit that adhered to the contours of the body, and added belts, straps and chains to lend the figure extra interest. I also gave her a pair of metallic gauntlets, which make her hands appear more powerful.

This part of the design process is where the character develops, so it is important to think about what details to add and where to position them. You can gain inspiration for different looks in many places, from the high street and fashion shows to books, magazines, movies, video games or the Internet. For this character I referenced photographs of medieval armour. When drawing the chains, think about the thickness of each link and how they interlock with each other (Figure 5), and try to render this accurately.

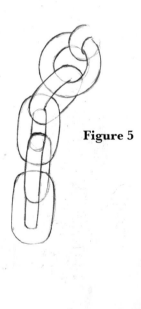

Figure 5

STEP 6

Having established the main shapes and position of the clothing and any embellishments, these can now be decorated with finer detail. When it came to drawing the detail on the gauntlet (Figure 6), I took inspiration from a book on medieval armour (Figure 7). It is essential to have a point of reference when drawing an unusual item, if you hope to represent it correctly.

Before applying the first layers of shading, I decided to alter the clasp for the cape. I felt the original shape was a bit boring, so I changed it to a more interesting demonic skull shape (Figure 8).

Figure 6

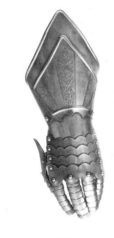

Figure 7

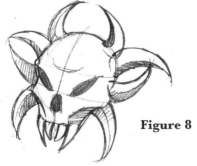

Figure 8

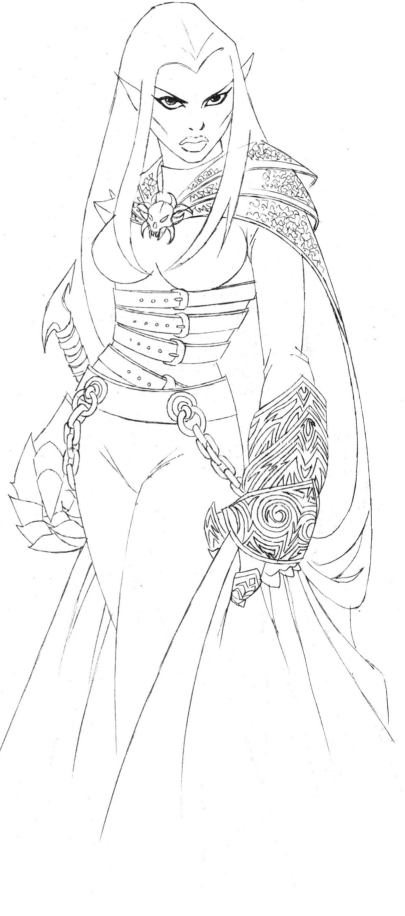

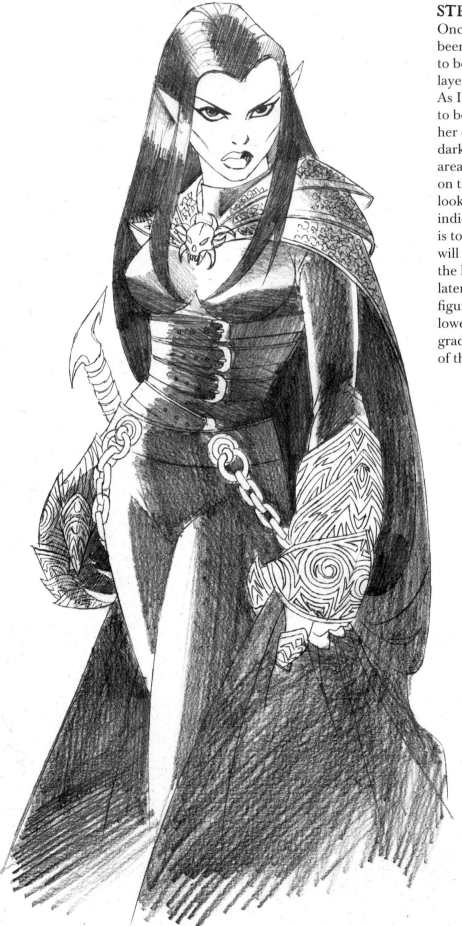

STEP 7

Once the outline drawing has been finished, areas of tone need to be blocked in. I applied an even layer of shading for the base layer. As I knew there were not going to be too many layers of tone for her clothing, I applied an overall dark tone using a B lead. Leave areas of white for the highlights on the left-hand side (as we are looking at the picture), which indicate that the main light source is to the left of the picture. This will make it easier to strengthen the highlights with an eraser later. As this drawing is not a full figure and does not include the lower legs and feet, the shading gradually fades out at the bottom of the page.

STEP 8

Once you are happy with the base layer, softly blend it with tissue paper, then apply a second layer for the darker tones on her hair (Figure 9), the underside of her breasts and the inside and folds of her cape. For blending the hair I used a No. 5 blending stump (Figure 10).

Figure 9

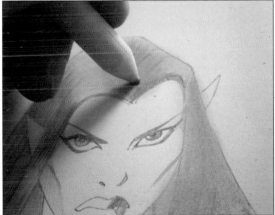

Figure 10

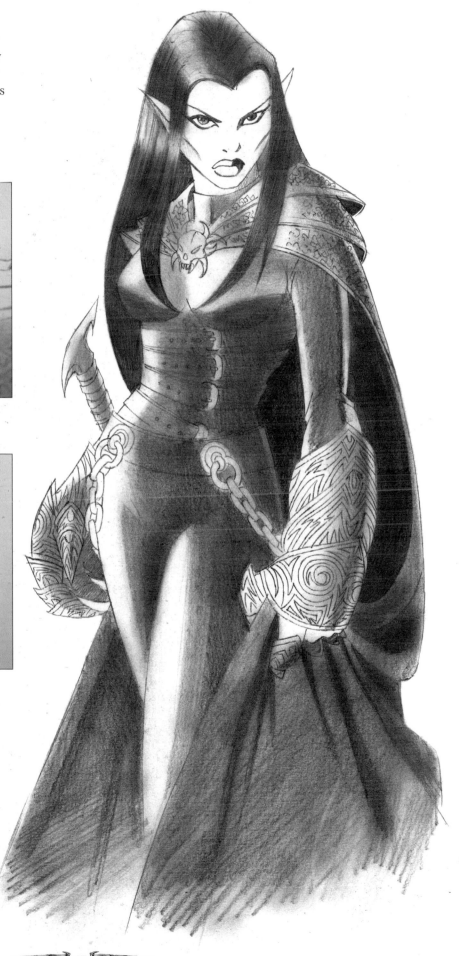

STEP 9

Once the blending is correct, apply highlights
with an eraser. Use the fine edge of a plastic
eraser or mould a putty rubber into a fine
point to get into the more fiddly details, such
as the belts and chains (Figure 11). Define the
highlights by chiselling away with the sharp
edge of an eraser. Think of the eraser as adding
and not removing – rather as if you were
painting white highlights with permanent white
gouache. The light source is mostly coming
from the left of the figure as we are looking at
her, so the bolder highlights are on the left-hand
side, with some less dominant ones to the right,
indicating a weaker light source to the right.

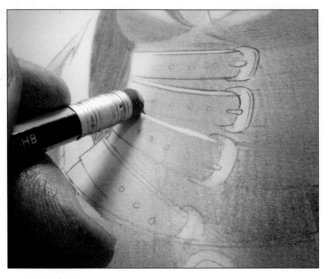

Figure 11

Having applied all the final shading and
highlighting, clean up around the outside of
the drawing with an eraser, being careful not
to erase any of your drawing (Figure 12).

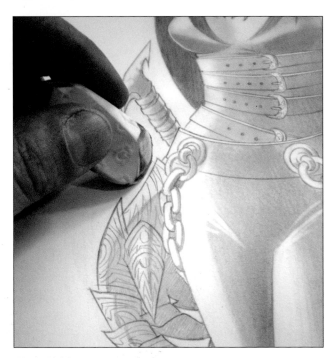

Figure 12

Finally, go around the drawing using a sharp
HB pencil and add a crisp, hard line to any
areas that need defining (Figure 13), such as
the outline of the hair and cape and the detail
of the gauntlet and belt. The finished drawing
can be seen on the facing page.

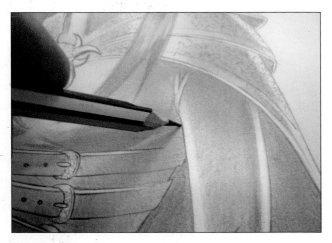

Figure 13

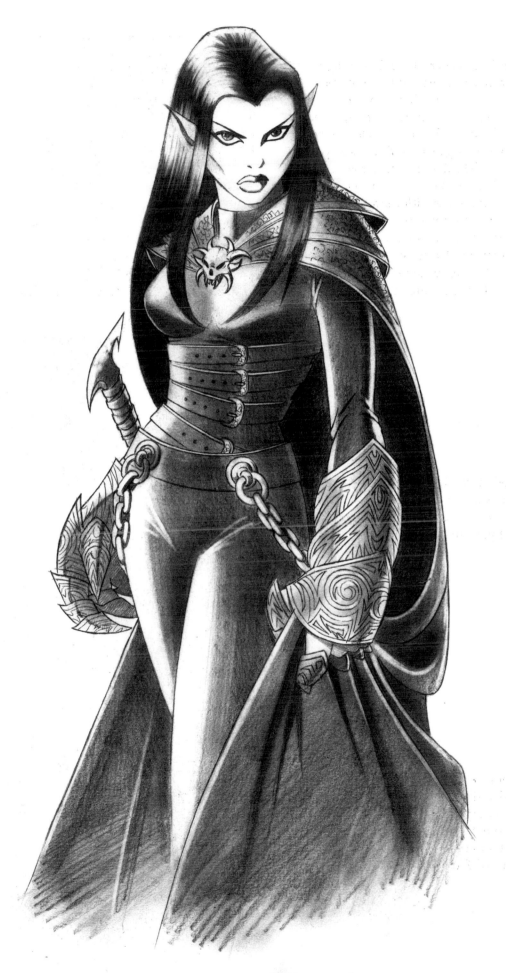

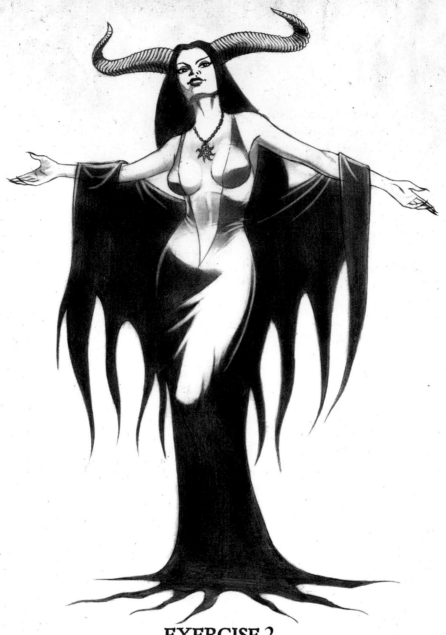

EXERCISE 2

ENCHANTRESS

(Beginner's Exercise)

Here is another simple figure-drawing exercise for you to have fun with. As with the first one, this introductory tutorial is designed to help you become familiar with basic techniques and develop your confidence.

The inspiration for this drawing came from the characters Darkness (played by Tim Curry in Ridley Scott's *Legend*) and Malecifent (from Walt Disney's *Sleeping Beauty*). Darkness is a demonic figure with massive bull-like horns, and Malecifent wears a headdress/helmet with huge twisting horns, and a long black gown. Even though Malecifent is evil and not meant to be the most attractive character in the movie, there was something strangely appealing about her.

STEP 1

Start by drawing the skeletal frame. Notice that, as in the first exercise, the twist of the spine and the angle of the hips and shoulders establish the attitude of this pose. All the body weight is on the right leg, which is straight, making the left leg bend at the knee. The shoulders tilt down towards the raised hip. The head is tilted back slightly. Before moving on to the next stage, make sure you have successfully drawn a balanced pose.

STEP 2

When you are happy with the pose, flesh out the body frame with simple geometric shapes.

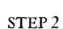

STEP 3

Now round out your figure with more natural curves. Be careful not to make it look masculine; this is a female body, so keep to slender shapes and pay attention to the arms and waist.

Figure 1

STEP 4

Once you are happy with the shape, erase the guidelines on the body and concentrate on adding detail to the head. Figure 1 shows a close-up of the face. This may be a little tricky to draw at first, but try a few practice attempts on scrap paper first. Notice that the head is tilted back, making the underside of the chin and nose visible. The trick is to avoid making her look as though she has a pig-like snout. I have kept to simple lines, eliminating unnecessary detail that could make her face look unattractive.

STEP 5

You can now add the horns and outerwear. I chose to keep the shawl simple, with no embellishments except for the fringing details at the bottom.

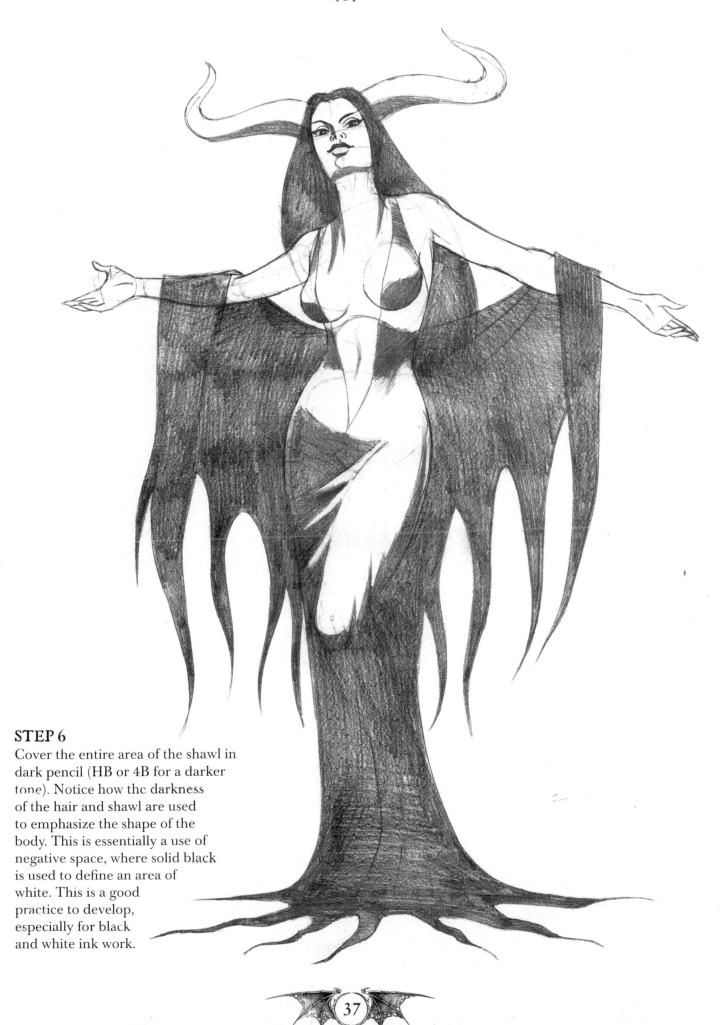

STEP 6

Cover the entire area of the shawl in
dark pencil (HB or 4B for a darker
tone). Notice how the darkness
of the hair and shawl are used
to emphasize the shape of the
body. This is essentially a use of
negative space, where solid black
is used to define an area of
white. This is a good
practice to develop,
especially for black
and white ink work.

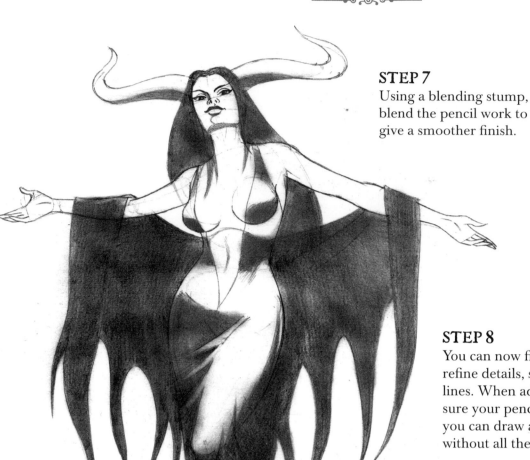

STEP 7

Using a blending stump, blend the pencil work to give a smoother finish.

STEP 8

You can now fine-tune the drawing and refine details, such as darkening and defining lines. When adding detail to the horns make sure your pencil has a sharp point so that you can draw a large amount of ridge detail without all the line work merging.

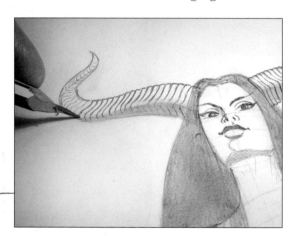

STEP 9

Use the fine edge of an eraser to create highlights on the horns, gown and shawl. This will give extra detail to the clothing and interest to the drawing.

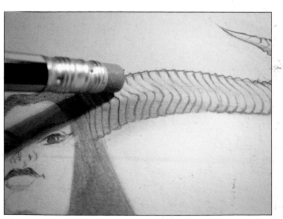

STEP 10

Now assess the picture as a whole. Does anything need adding? I felt the space created by the open cut of her dress looked a bit too bare and needed some kind of amulet or chain to create a bit more interest. Notice how the design of the amulet echoes the shapes of the dress and shawl. Always try to make all the elements of your drawing look like they belong together.

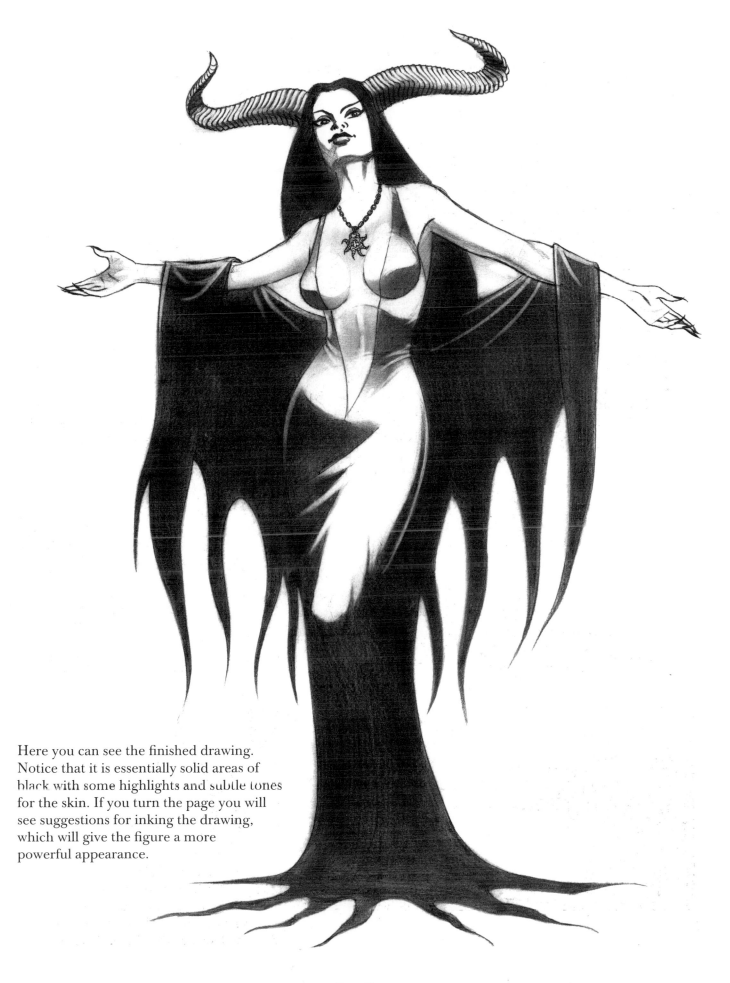

Here you can see the finished drawing.
Notice that it is essentially solid areas of
black with some highlights and subtle tones
for the skin. If you turn the page you will
see suggestions for inking the drawing,
which will give the figure a more
powerful appearance.

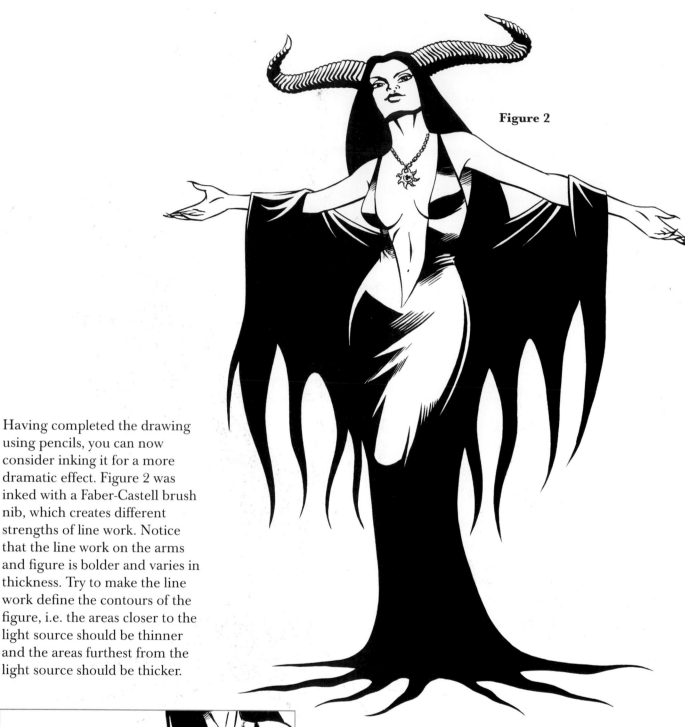

Figure 2

Having completed the drawing using pencils, you can now consider inking it for a more dramatic effect. Figure 2 was inked with a Faber-Castell brush nib, which creates different strengths of line work. Notice that the line work on the arms and figure is bolder and varies in thickness. Try to make the line work define the contours of the figure, i.e. the areas closer to the light source should be thinner and the areas furthest from the light source should be thicker.

This alternative image (Figure 3) was inked with a sable No. 2 Winsor & Newton watercolour brush, with the result that the line work is a little looser in areas, creating a softer effect.

Figure 3

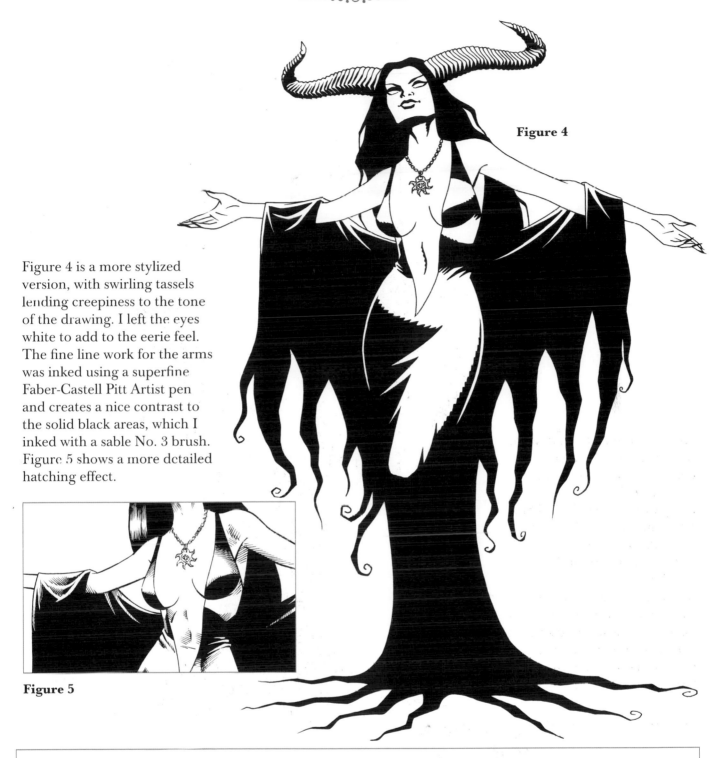

Figure 4

Figure 4 is a more stylized version, with swirling tassels lending creepiness to the tone of the drawing. I left the eyes white to add to the eerie feel. The fine line work for the arms was inked using a superfine Faber-Castell Pitt Artist pen and creates a nice contrast to the solid black areas, which I inked with a sable No. 3 brush. Figure 5 shows a more detailed hatching effect.

Figure 5

INKING TIPS

There are many things to consider when inking, including your posture, how you hold the pen or brush and which part of the drawing to ink first.

• If you are going to spend a lot of time drawing you will need to consider how you sit and what you rest your pad or paper on while you draw. Most professional artists work at an angled drawing board. Drawing on a flat surface is not only bad for your back, it can actually affect how you draw your artwork. It certainly influences how you view your artwork as you draw it; an angled drawing board allows you to see your work from a better perspective, whereas a flat surface can cause distortion. If a drawing board is beyond your budget, try a lap board, which you can rest against a table or on your lap.

• If possible, sit near a window that gives you as much natural light as possible. If you are working under a lamp, try using a daylight bulb.

• If you are using a brush, try holding it at a high angle, so that it is almost vertical. This will give you more control over the brush. You may find that a low angle inhibits your movements.

• Conversely, if you are using a pen to ink work, you may find that holding the pen at a low angle is best, as a high angle often does not give enough control.

• If you are right-handed it is a good idea to start work from the left-hand side of the drawing, so that your hand moves away from your freshly laid ink and you avoid smudging. If you are left-handed, work from right to left.

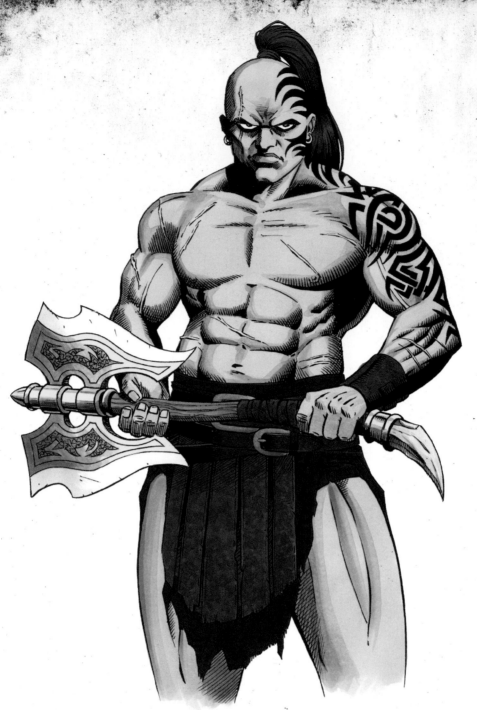

EXERCISE 3

❖───◦❖◦───❖

TRIBAL WARRIOR

❖───◦❖◦───❖

(Beginner's Exercise)

This is an exercise in character development, inking and colouring. Learning to develop a figure from nothing other than ideas in your head is an important process in fantasy art. When I have been commissioned to create a character, whether for a video game or as concept art for a film, I go through a process of making a collection of rough sketches. Each of these explores a direction of thought and how the character could look, and the final design will sometimes be a combination of different parts of each concept sketch. This is probably the most fun part of creating fantasy art as you don't always know where the chain of thought will take you.

STEP 1

Here we have a collection of sketches that show the various stages of development for a character. I began by scribbling out a rough skeleton to determine the pose of the figure. I decided that he will be carrying a weapon which I roughly indicated with a stick.

STEP 2

The next stage is to decide on the build of the character, exploring whether the body will be muscular or slightly built.

STEP 3

Having chosen the body shape, it is time to add detail to the figure and to settle on the type of weapon. For this exercise I have chosen an axe for the warrior to wield, but you can opt for whichever weapon you like (Figure 1 shows an alternative).

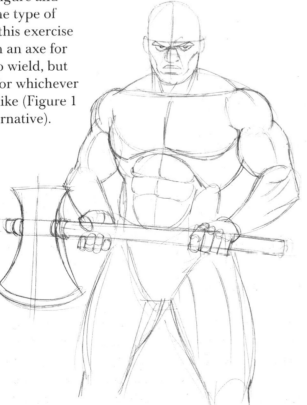

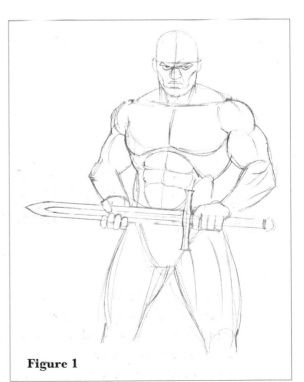

Figure 1

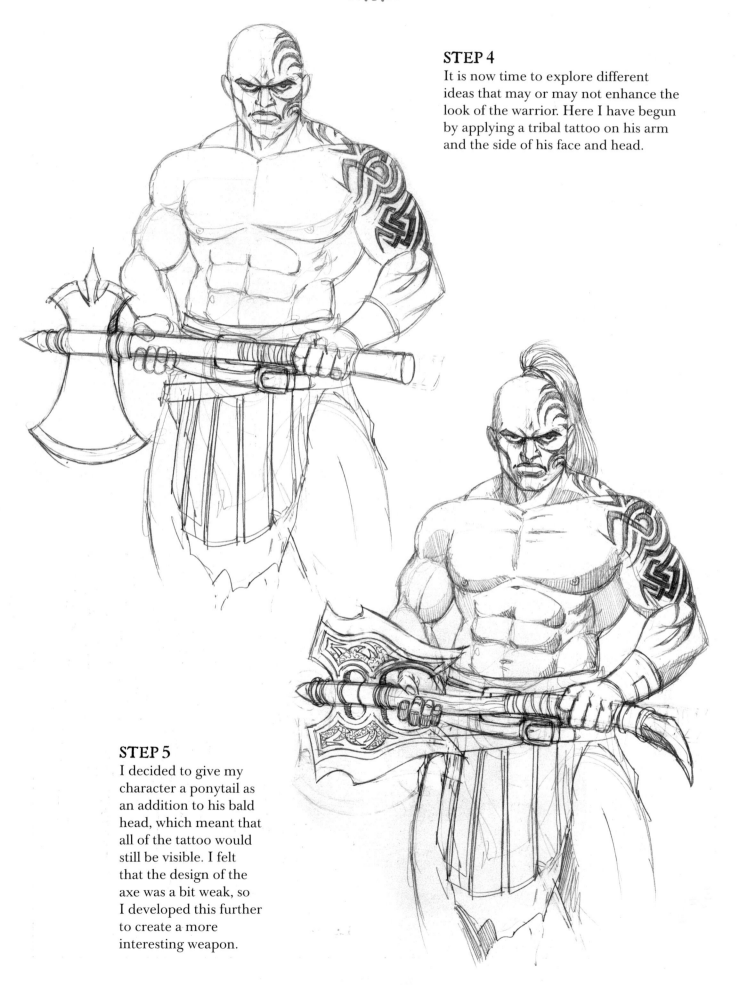

STEP 4
It is now time to explore different ideas that may or may not enhance the look of the warrior. Here I have begun by applying a tribal tattoo on his arm and the side of his face and head.

STEP 5
I decided to give my character a ponytail as an addition to his bald head, which meant that all of the tattoo would still be visible. I felt that the design of the axe was a bit weak, so I developed this further to create a more interesting weapon.

ADDING ARMOUR

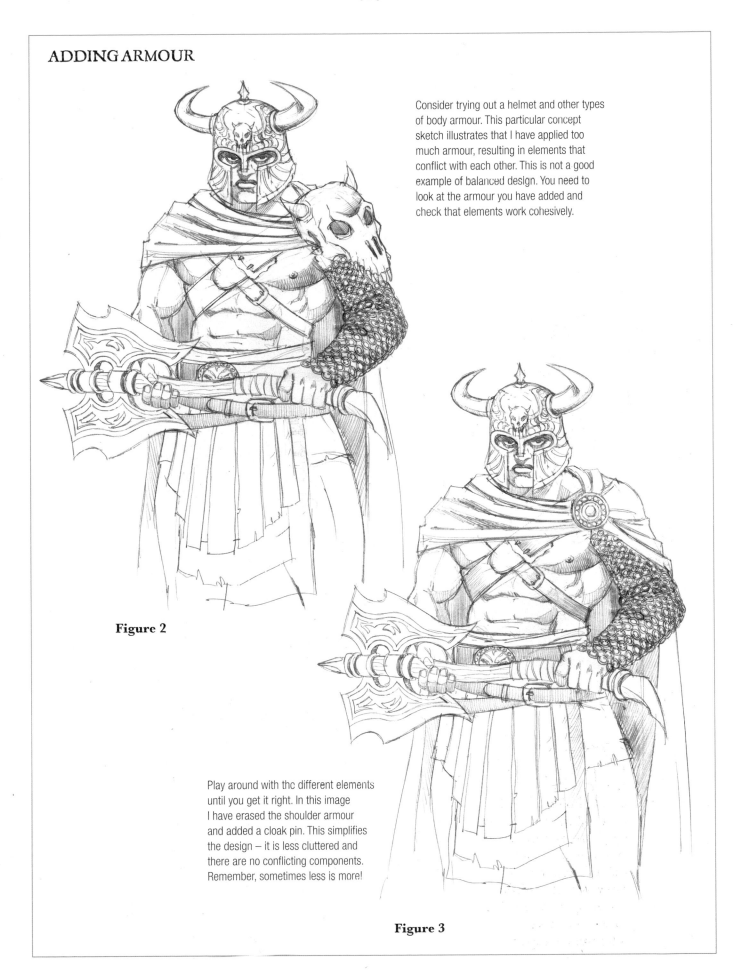

Consider trying out a helmet and other types of body armour. This particular concept sketch illustrates that I have applied too much armour, resulting in elements that conflict with each other. This is not a good example of balanced design. You need to look at the armour you have added and check that elements work cohesively.

Figure 2

Play around with the different elements until you get it right. In this image I have erased the shoulder armour and added a cloak pin. This simplifies the design – it is less cluttered and there are no conflicting components. Remember, sometimes less is more!

Figure 3

STEP 6

Having been through the development process you should have a figure that you are happy with, and can now go ahead and apply ink. I have chosen to ink the original tribal warrior, without the armour and with the tattoo, as I felt it was the better character design of the two. The starkness of his mostly bald head allows you to focus on his fierce stare and facial scar. Also, because he has no armour, the scars on his body are visible, making him look more brutal. You may want to start inking the most interesting part of the drawing first, which for me is the head. I used a superfine pen for the facial details, especially the eyes.

STEP 7

A superfine pen can also be used for the hatching, as shown. I applied more pressure to the nib at the beginning of the stroke to create a heavier line, and gradually released the pressure towards the end to create a lighter line. This is best executed in a quick stroke, so do not think too much about how much pressure to apply at the beginning and the end. It is best to practise a few times on a scrap sheet of paper first.

STEP 8

Once you have completed the head, move on to other areas. I continued with the superfine pen for the hair and scars (Figure 4) and then finished off the solid black areas using a brush pen. Using an actual brush and Indian ink would do the job just as well. Notice that I have applied a thicker weight of line on the underside of muscles such as the chest (pectorals) and biceps and embellished them with hatching to create the appearance of roundness of shape.

Figure 4

STEP 9

You may have to pause and consider different options during the inking process. In this case, I was not certain whether to ink the tattoos in solid black or to sketch them in thin line to be filled in with a coloured pen later, or even to leave the arm blank and draw the tattoo with a colouring pen. Leaving the tattoo in outline (as shown here) would make it easier to colour by keeping the colour within a confined space. Applying the tattoo with a coloured pen, however, would give an appealing finish. In the end I chose to ink in the tattoo using solid black, which looks powerful and also works well once the rest of the drawing has been coloured (Figure 5, below).

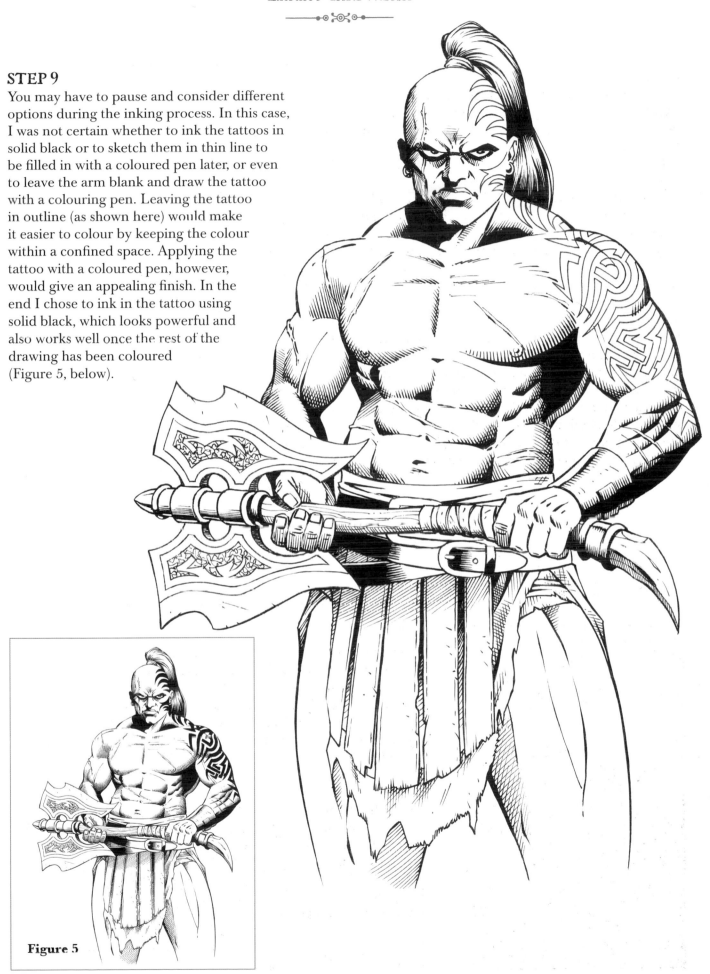

Figure 5

STEP 10

You can now move on to colouring the picture. To colour this drawing I primarily used Copic markers (see page 14). I began by laying down the base layers of skin tone, hair, clothing and the weapon. For the skin, I used Copic E53 Raw Silk and a Blush Letraset Pro marker (Figure 6). For the hair, leather straps and belt I used Copic E39 Leather. For the protective leather straps hanging from the belt I used Copic E35 Chamois (Figure 7), and for the loincloth I used Copic E09 Burnt Sienna (Figure 8).

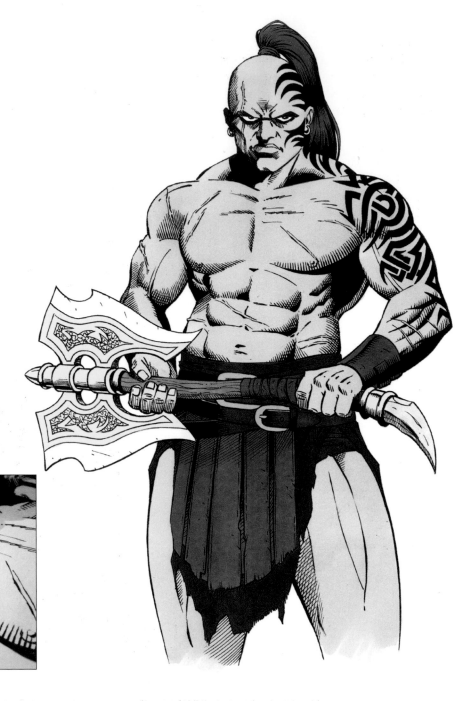

Figure 6

Figure 7

Figure 8

STEP 11

The base layer of colour should then
be built upon using layers of darker
tones. Lighter, subtle tones can be
achieved by using the same colour
marker over the base layer once it
has dried. Start by finishing the
skin layers. Here I used Copic
E53 Raw Silk, E11 Barely
Beige and E31 Brick Beige
(Figure 9 and Figure 10).

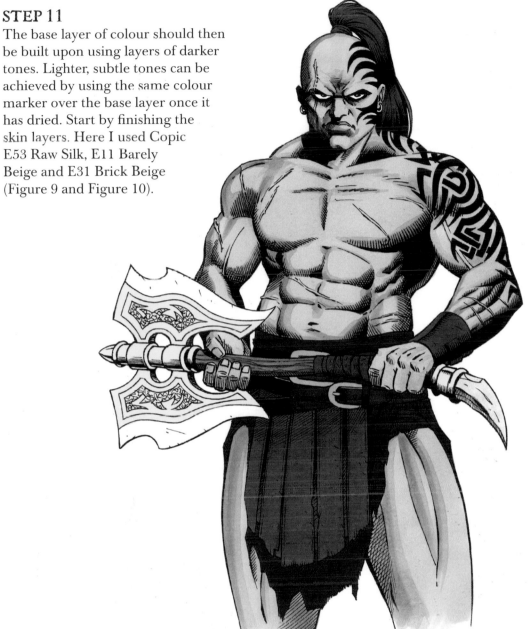

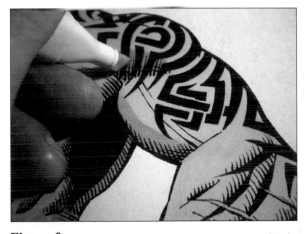

Figure 9

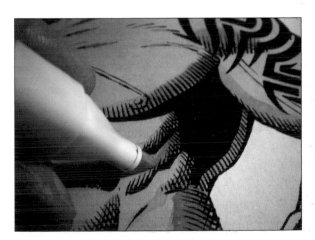

Figure 10

STEP 12

Having worked on the skin tones, turn your attention to the weapon, clothing and armour. I built the warmer tones of the axe head using Copic Y15 (Cadmium Yellow) and Y21 (Buttercup Yellow). The darker tones of the loincloth (Figure 11), leather (Figure 12) and hair (Figure 13) were created by adding a layer of E27 (Africano) followed by a layer of Copic W5 (Warm Grey). I did not want the leather to have a totally smooth appearance, so I purposely created an uneven layer by applying more of the Warm Grey in some areas than in others to create a worn effect. Using a marker with a nib that is drying up is good for this effect.

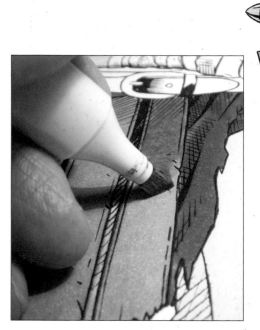

Figure 11

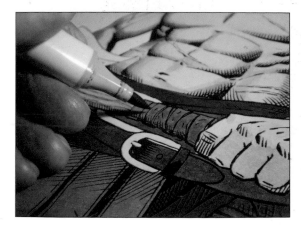

Figure 12

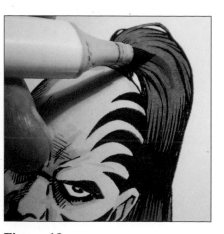

Figure 13

STEP 13

Finally, add the finishing touches to blend the colours. I applied a Copic W2 (Warm Grey 2) and W3 (Warm Grey 3) to the parts of the skin I wanted to appear darker, in particular the left side (as we are looking at him) of the figure, the head, shoulder, shadowed areas of the hands and the outer line of the leg – basically anywhere where there was shadow that I felt needed some extra tone to blend lighter and darker areas. I used some thinned white gouache to make the scar tissue more prominent. I used a Copic W3 to add extra tone to the axe head.

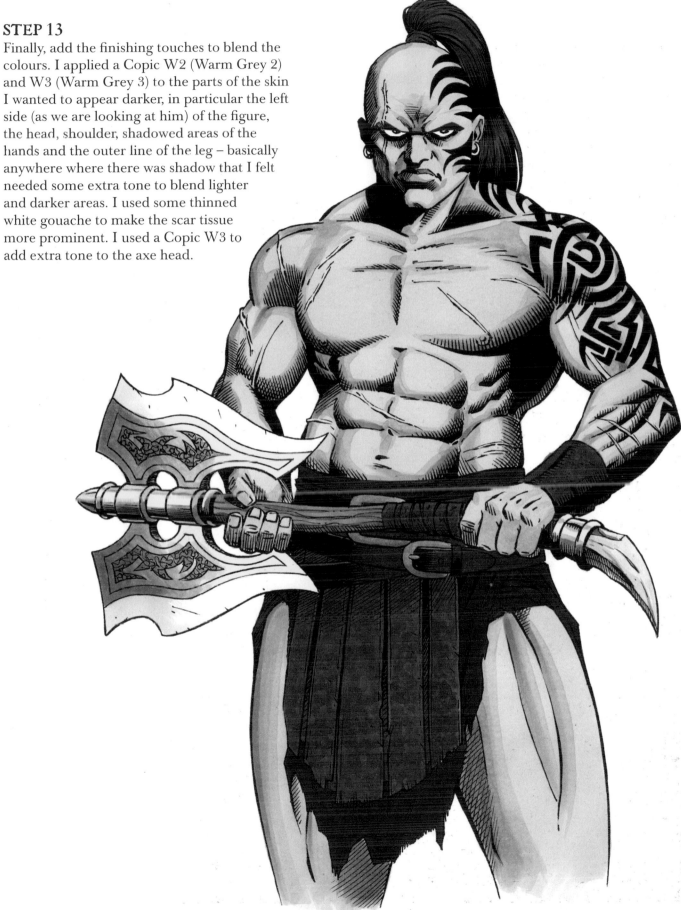

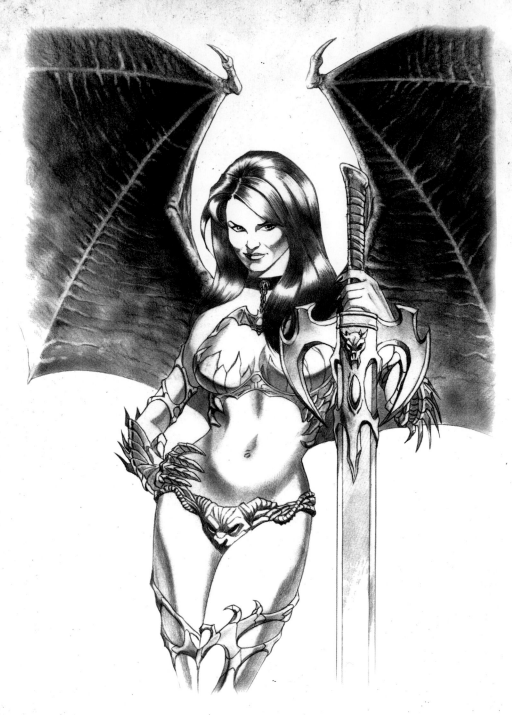

EXERCISE 4

✦❖✦

Winged Warrior

✦❖✦

(More Complex Exercise)

This is the first of the more complex exercises in this book. As with the Enchantress exercise on pages 34-41, I wanted to create a female character who, although she has anatomical additions that in real life most people would not find attractive, would still project a sexually provocative image.

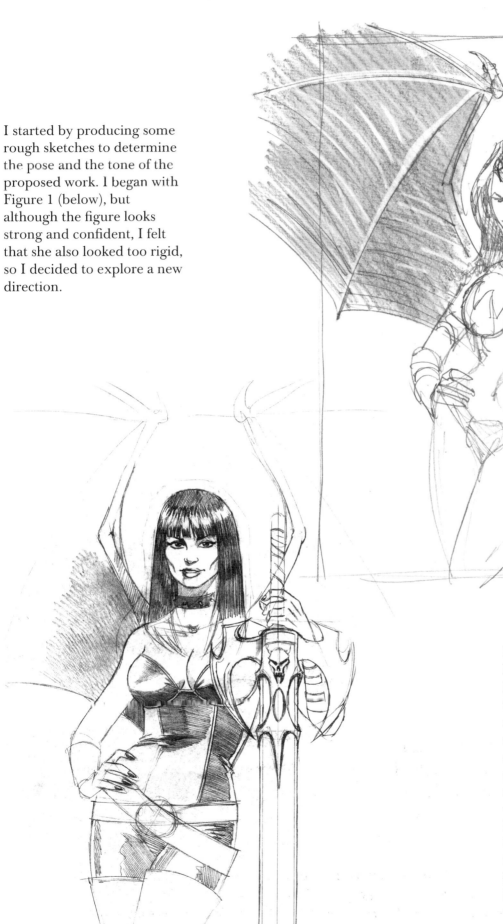

I started by producing some rough sketches to determine the pose and the tone of the proposed work. I began with Figure 1 (below), but although the figure looks strong and confident, I felt that she also looked too rigid, so I decided to explore a new direction.

Figure 2

In Figure 2 I altered the look of the warrior, giving her wavy hair and lowering the angle of her head, which makes her appear more seductive but retains the confident, dominant look. I also rethought the clothing and, although this figure is wearing less, the design of her outfit is more interesting. Once I was satisfied with the thumbnail sketch I proceeded to develop this into a finished piece of work.

Figure 1

STEP 1

It is best to start with a skeletal frame when you are a beginner, but once your confidence and ability have developed enough you may find that you can bypass this stage and go straight to a rough figure sketch.

STEP 2

Flesh out the outer frame. As with previous exercises in this book, the balance of the pose is very important. Pay attention to the curve of the spine and the angle of the hips.

STEP 3

Roughly sketch out the shape of the wings,
which are based on a bat's wings (Figure 3).
As you can see in the diagram of a bat's wing
(Figure 4), the bone-like ridges that separate the
span of skin are actually fingers, and the claw at
the top of the wing is a thumb.

Figure 3

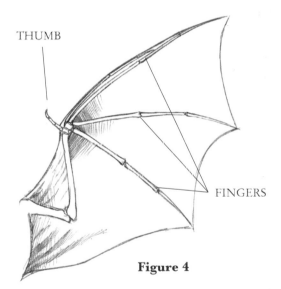

THUMB

FINGERS

Figure 4

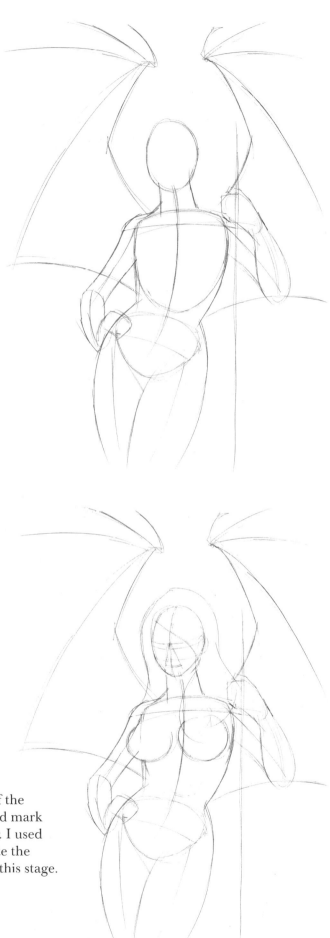

STEP 4

Sketch in the shape of the
breasts using ovals and mark
the outline of the hair. I used
simple curves to create the
shapes for the hair at this stage.

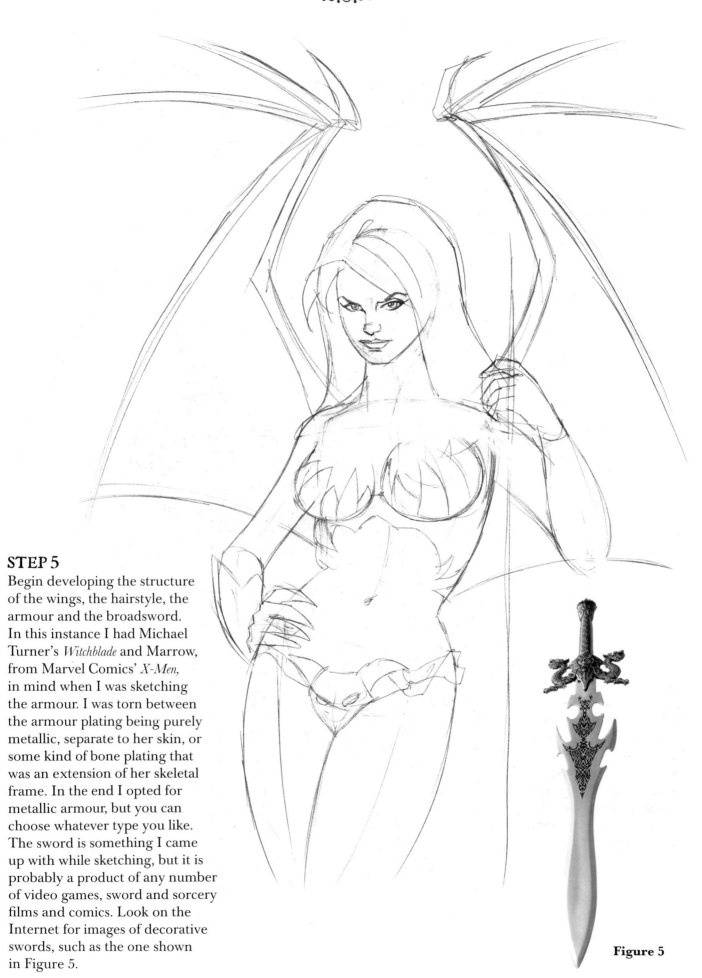

STEP 5

Begin developing the structure of the wings, the hairstyle, the armour and the broadsword. In this instance I had Michael Turner's *Witchblade* and Marrow, from Marvel Comics' *X-Men*, in mind when I was sketching the armour. I was torn between the armour plating being purely metallic, separate to her skin, or some kind of bone plating that was an extension of her skeletal frame. In the end I opted for metallic armour, but you can choose whatever type you like. The sword is something I came up with while sketching, but it is probably a product of any number of video games, sword and sorcery films and comics. Look on the Internet for images of decorative swords, such as the one shown in Figure 5.

Figure 5

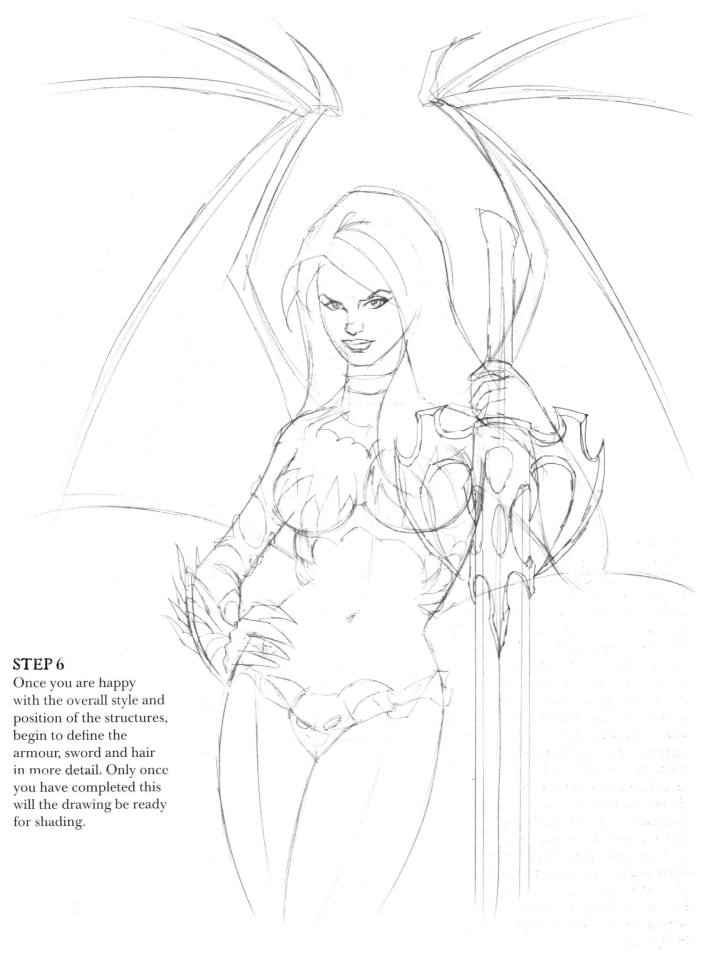

STEP 6

Once you are happy
with the overall style and
position of the structures,
begin to define the
armour, sword and hair
in more detail. Only once
you have completed this
will the drawing be ready
for shading.

STEP 7
Begin shading the hair, laying down the first layers of tone, but leaving highlights in areas to indicate a healthy shine that will contribute to the figure's appeal.

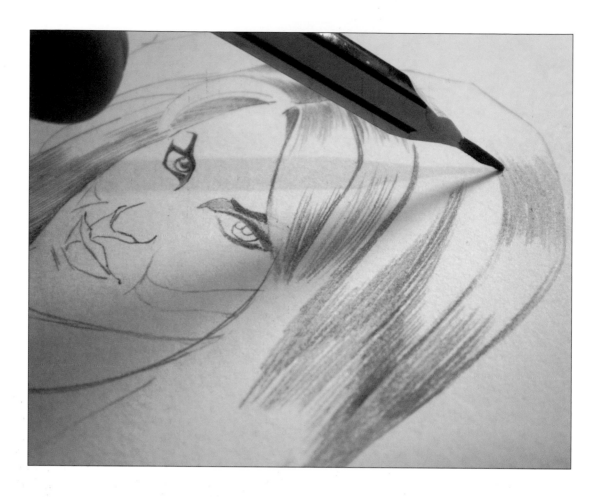

STEP 8
You can now shade the face. Here, the main features of the face have been kept simple and uncluttered. The eyebrows are simple, with chiselled curves that merge with the heavy eyeliner effect around her eyes. Getting the face right is crucial for creating a character with visual appeal. Notice that I have not drawn the entire nose. It is mostly defined by lighting.

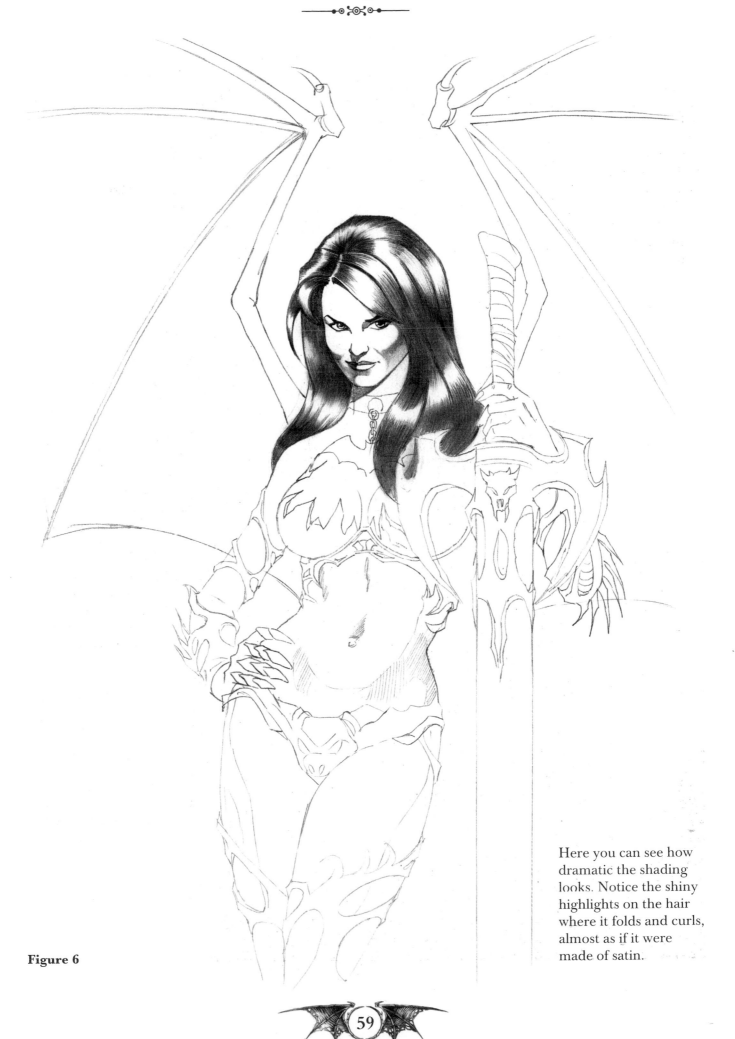

Figure 6

Here you can see how dramatic the shading looks. Notice the shiny highlights on the hair where it folds and curls, almost as if it were made of satin.

STEP 9

Apply some delicate pencil work to shape the contours of the body. When shading the skin be careful not to overwork it. Notice that only soft shading has been used to establish the contours of the body, such as the breasts, the tummy and the outer areas of the legs. The areas that will be most exposed to the light have been left white.

STEP 10

Now blend to create a smoother appearance. Use either a large blending stump or some tissue paper.

STEP 11

A second layer of slightly darker shading can now be laid over the top. Just apply a little more pressure than when creating the first layer. This second layer fades out towards the top of the tummy curve and gradually darkens towards the middle, before gradually fading out to the hips and the groin armour.

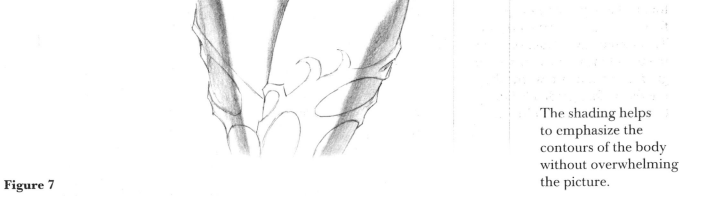

Figure 7

The shading helps
to emphasize the
contours of the body
without overwhelming
the picture.

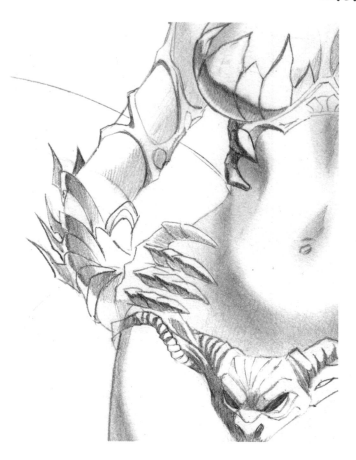

STEP 12

You can now refine the look of metallic armour and add shading. On the breast cup the shading begins at the point where the breast curves away from the light, and a harder edge is applied. Notice that the shading begins to fade to light at the bottom left. This indicates a secondary light source, which helps prevent the shading from appearing too heavy.

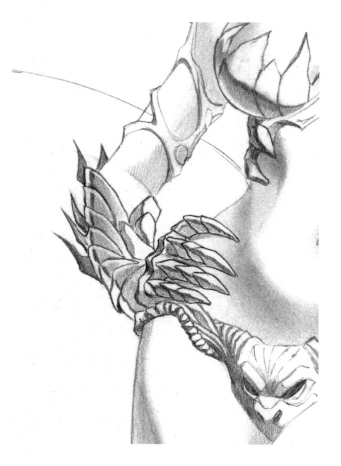

STEP 13

The same approach should be applied to the glove, except that here the hard tone should be on the outer edge, with the graduation to softer shading travelling towards the right. This indicates that the secondary light is stronger nearer to the glove.

STEP 14

Once you are happy with the shading, highlights can be applied with an eraser to the outer edges of the joints and moulds of the armour to lend an extra dimension to the drawing.

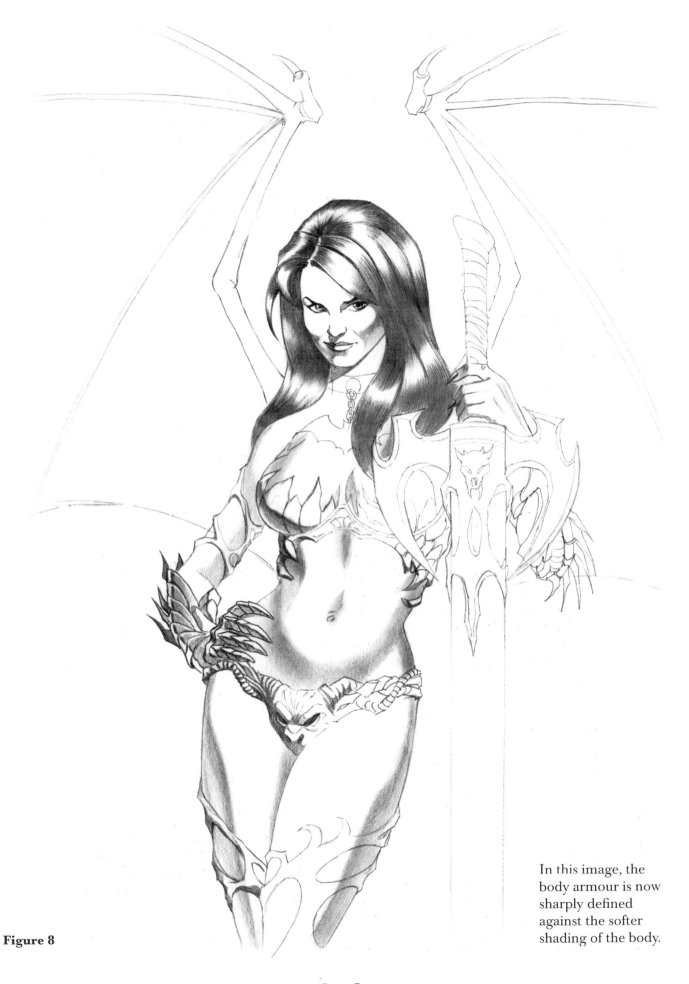

Figure 8

In this image, the body armour is now sharply defined against the softer shading of the body.

STEP 15

It is now time to turn your attention to the wings, which are based on those of a bat. Keep your photo reference to hand when adding detail to the wings (Figure 9). To start, shade the entire area of the wing using an HB or a B pencil and blend it with a blending stump or piece of tissue.

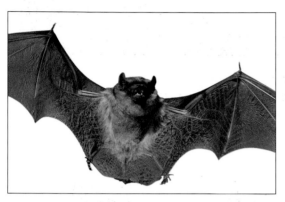

Figure 9

STEP 16

To create the texture of the wings, add more shading in some areas to create large spots of tone. These can then be blended to give a smoother appearance.

STEP 17

Next, highlight the fingers of the wings using an eraser. Notice in the photograph that the drawing is upside down. Whether I am using inks or pencils, I like to be able to move the paper around (rather than moving myself around the paper) to get to areas that would be difficult to access if it were taped down to a drawing board.

STEP 18

Further texture can then be added by shading along the outside of the erased highlight to give the finger a more three-dimensional appearance.

STEP 19
Create the textured skin running between each finger by using the flat edge of a pencil to create a ragged, uneven line.

STEP 20
Highlights can then be applied to the textured lines using an eraser.

Figure 10

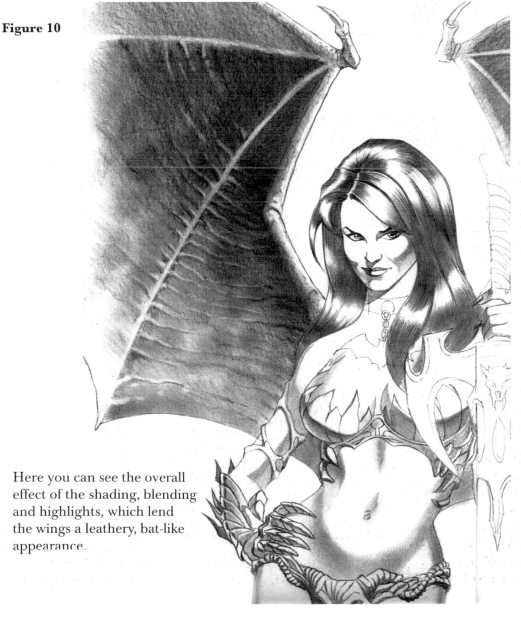

Here you can see the overall effect of the shading, blending and highlights, which lend the wings a leathery, bat-like appearance.

STEP 21

Once all the shading and textures have been applied, add a fine, crisp line round the detailed parts of the armour, the edge of the figure and any other areas that need that extra bit of lift. If there are any parts of the drawing that are blurred or smudged, these are the areas to tighten up.

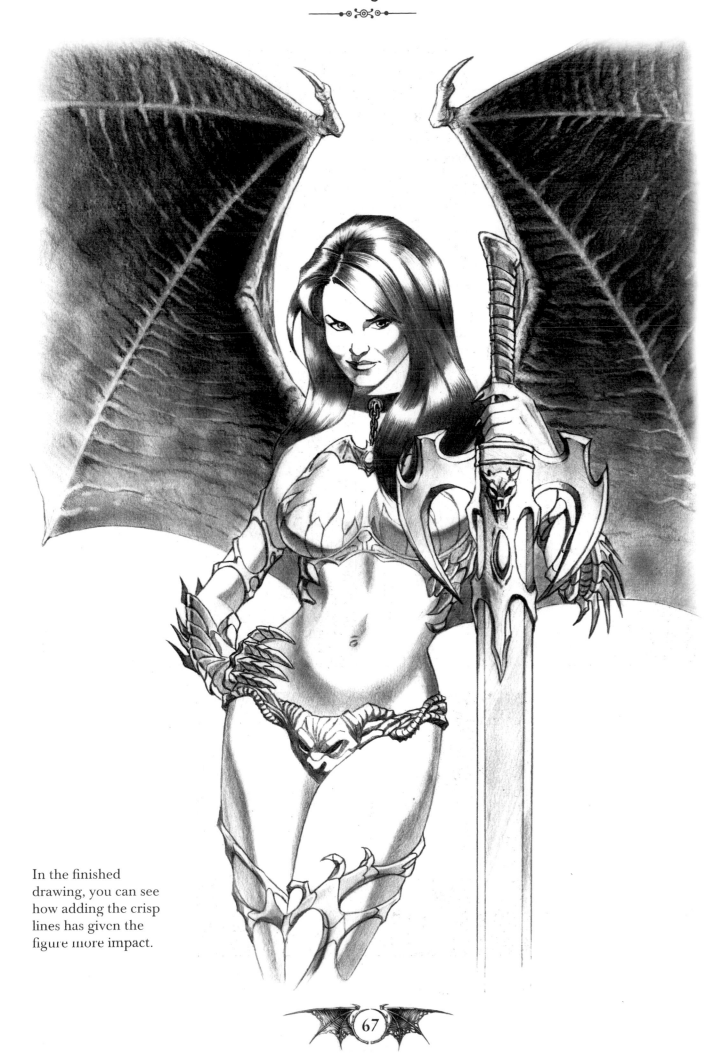

In the finished drawing, you can see how adding the crisp lines has given the figure more impact.

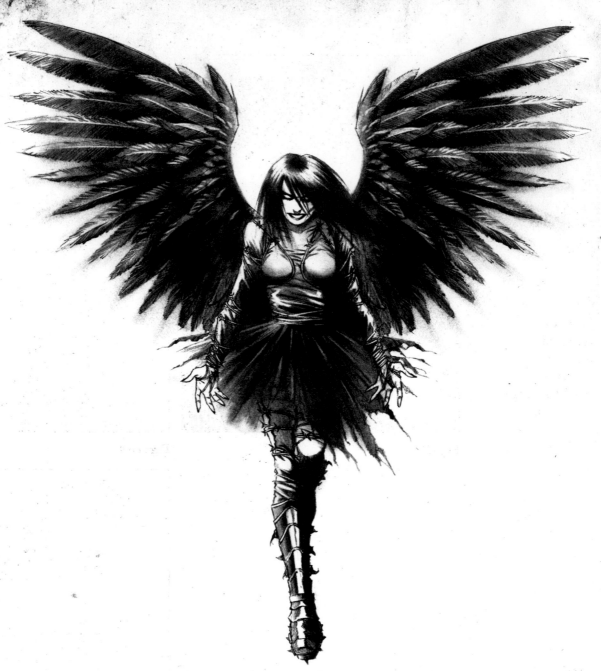

EXERCISE 5

DARK ANGEL

(More Complex Exercise)

For this drawing, I drew inspiration from Alex Proya's movie *The Crow*, starring Brandon Lee as the title character, which is based on the comic book of the same name by James O'Barr. I also based it partially on the character Pris from Ridley Scott's movie *Blade Runner*.

I liked the idea of creating a drawing that was the polar opposite of conventional angelic imagery, replacing white dove-like wings with huge black crow-like wings, and a black leather/PVC look as opposed to a flowing white gown. The tutu suggests she is some kind of grungy gothic version of the black swan from the ballet *Swan Lake*, with chunky boots instead of ballet shoes.

Figure 1

Figure 2

Start by collating some photo reference material (Figures 1 to 5) to provide inspiration and enable you to draw features such as wings and PVC clothing correctly.

Figure 3

Figure 4

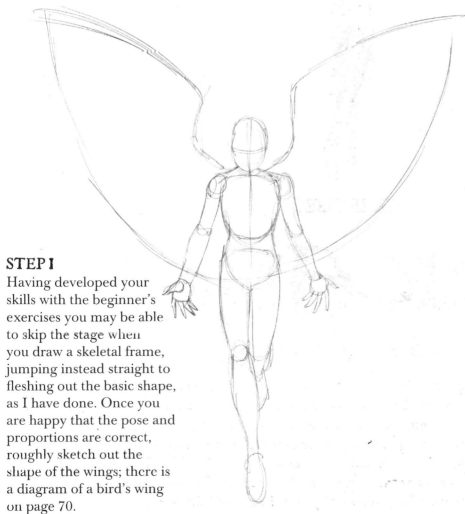

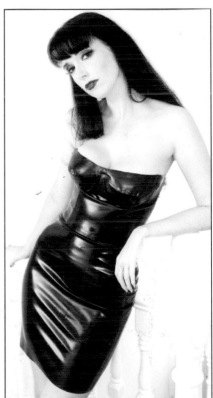

Figure 5

STEP 1

Having developed your skills with the beginner's exercises you may be able to skip the stage when you draw a skeletal frame, jumping instead straight to fleshing out the basic shape, as I have done. Once you are happy that the pose and proportions are correct, roughly sketch out the shape of the wings; there is a diagram of a bird's wing on page 70.

STEP 2

Start to develop the face and
define the body shape. Roughly
sketch the shape of the tutu.
At this stage the hair has been
kept to a simple shape that will be
developed later.

STEP 3

To make the appearance of the wings more
realistic it is a good idea to look closely at
various types of bird's wings. Figure 6 is a
diagram of the basic layout of feathers. It is
not essential for you to be familiar with bird
anatomy or to be an expert on wings, but a
general understanding of their construction
will help you to achieve a sense of realism. I
have based the wings loosely on those of a crow
or raven, taking the basic construction and
applying some artistic licence to create a more
symmetrical shape. The wings now appear to be
a hybrid of angel's and crow's wings.

Underside of wing

LESSER
UNDER-WING
COVERTS

GREATER
UNDER-WING
COVERTS

Figure 6

PRIMARIES

SECONDARIES

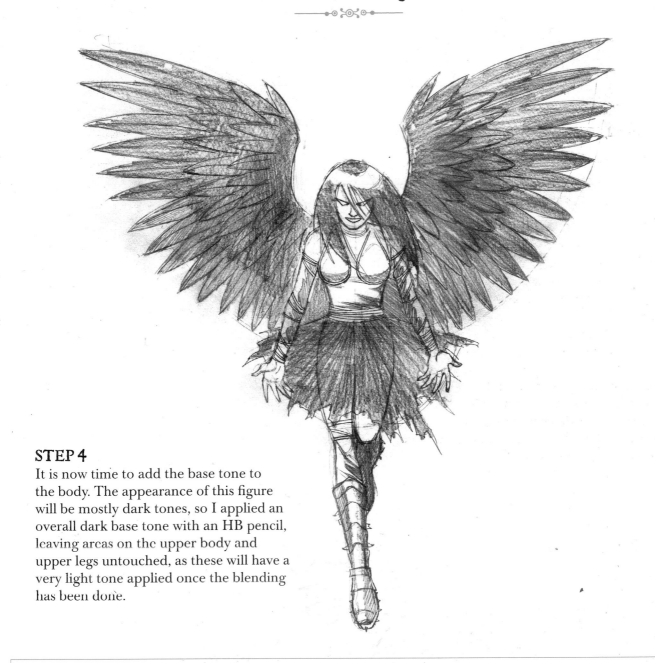

STEP 4

It is now time to add the base tone to the body. The appearance of this figure will be mostly dark tones, so I applied an overall dark base tone with an HB pencil, leaving areas on the upper body and upper legs untouched, as these will have a very light tone applied once the blending has been done.

ADDING DETAIL TO THE FACE, EYES AND HAIR

When constructing a young adult female's face it is important to keep the line work simple. To create an eerie, supernatural effect I left the eyes white, with no pupils or irises, and to make them stand out more I added heavy shading around the eye region (Figure 7).

To create the hair, work from the crown of the head outwards and downwards to form a simple outline (Figure 8). Block in shading, leaving white areas where the highlights are going to be (Figure 9), then blend the pencil work and reinstate highlights as necessary with an eraser (Figure 10).

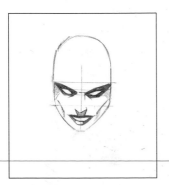

Figure 7

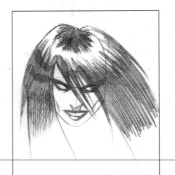

Figure 8

Figure 9

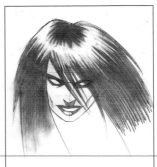

Figure 10

STEP 5

The pencil work needs to be blended. I wanted a softer effect than I could achieve with a blending stump so I used some tissue paper (Figure 11).

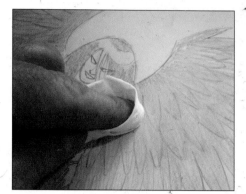

Figure 11

STEP 6

As this is a dark character, I felt that it would be appropriate to frame her against a background of dark clouds. To create the clouds, draw a very light outline of their position, leaving a white area behind the figure so that she stands out, then add a dark base tone to the clouds. This should then be blended and the edges of the clouds softened and shaped with an eraser (see page 11 for tips on creating cloud effects).

Other finishing touches can now be made. I used the fine edge of an eraser to highlight the feathers, and added highlights to the barbed wire and smaller folds in the material with a fine brush and some permanent white gouache. When creating highlights for a highly reflective surface such as PVC or patent leather, you will need to aim for really dark tones, or even solid black and harsh white highlights, as shown in Figure 5.

STEP 7

To finish the tutu, draw pencil lines from the hip area outwards towards the edge of the paper. The pencil work can then be blended together and some further darker pencil work laid over the top to create a ruffled effect. Use an eraser to create ragged outer edges, cutting back into the tutu in an uneven manner.

The pencil work for the wings should be gently blended together before the highlights are added. The feathers and other detailed areas such as the barbed wire can then be clearly defined with a sharp pencil to create a crisp line.

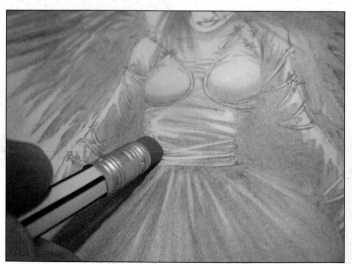

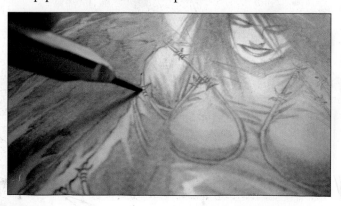

After completing the drawing I scanned it and
then imported it into Photoshop, where I adjusted
the hue to give it a bluish tone. This gives the final
image a moody atmosphere and adds impact.

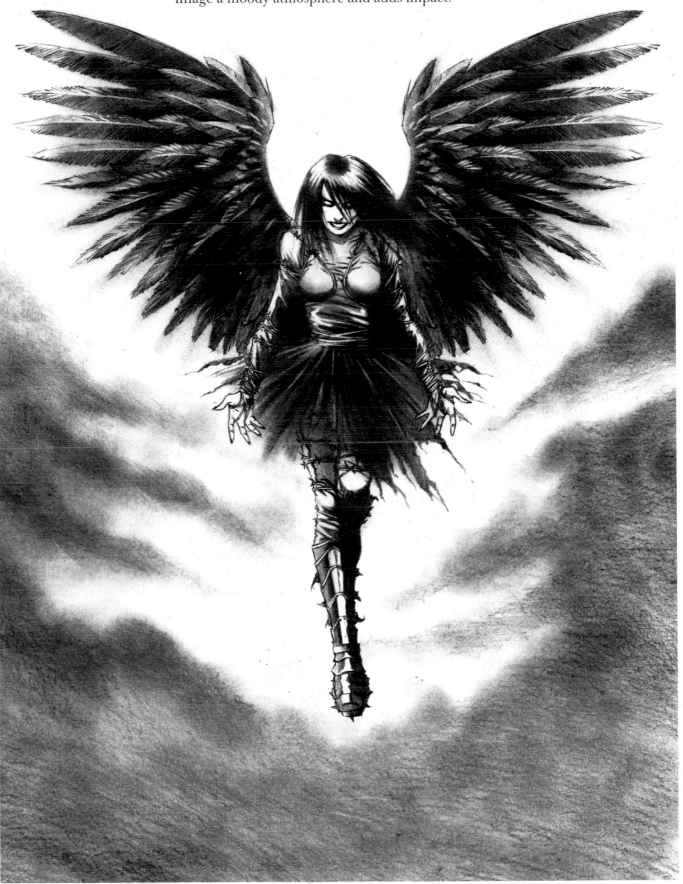

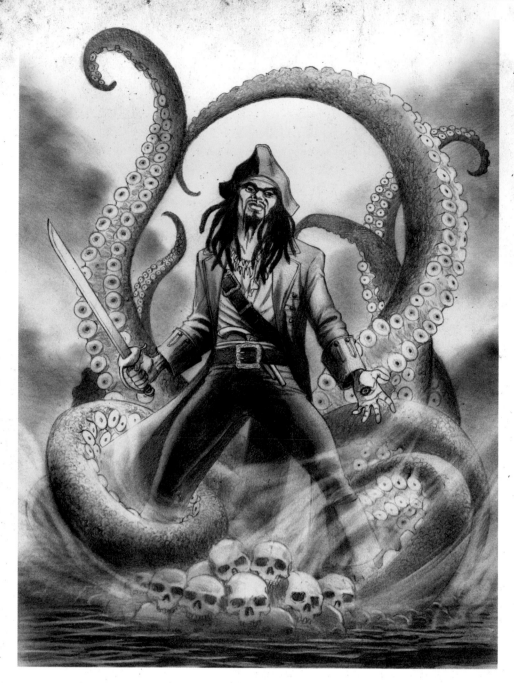

EXERCISE 6

◦•◦∘◦•◦

PÍRATE

◦•◦∘◦•◦

(More Complex Exercise)

During my childhood I saw many seafaring adventure movies. Some were sci-fi movies, such as *Twenty Thousand Leagues under the Sea* and *It Came From Beneath the Sea,* and some were 'high adventure' movies, such as *Treasure Island* and *Moby Dick.* The visual imagery of these and more modern feature films, such as Walt Disney's *Pirates of the Caribbean,* has had a strong impact on me and informs much of my artwork. Pirates, giant sea monsters and other supernatural creatures all make for great fantasy art and this exercise combines elements of all three.

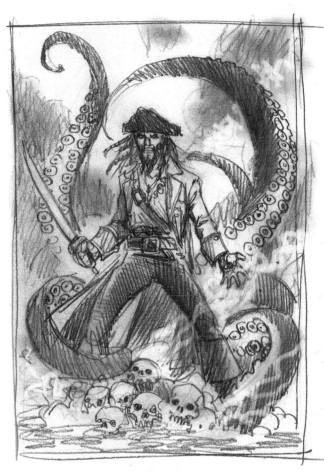

Figure 1

Before embarking on a piece of art it is good practice to produce some quick, rough sketches to determine the layout of your proposed work. In the professional world of illustration these rough sketches are known as thumbnails. They help an artist explore a number of concepts in a short space of time, using a minimal amount of expensive materials. I began this exercise by sketching a few thumbnail layouts to explore various compositions, before settling for the one that worked best (Figure 1).

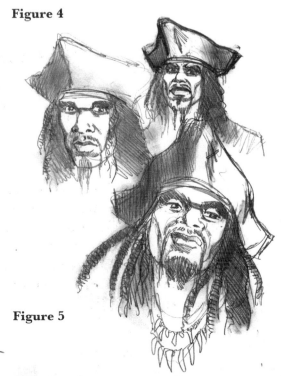

Figure 4

Having decided upon the composition of the picture as a whole, you need to think about what the main character will look like. The kind of pirate I had in mind was a person of Caribbean origin with dreadlocks. I sourced a few photo references (Figure 2 and Figure 3) and produced some quick character sketches (Figure 4 and Figure 5) to determine the look of my figure.

Figure 2

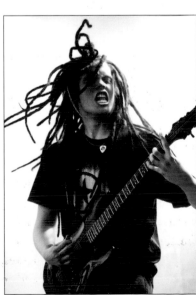

Figure 3

Figure 5

STEP 1

Generally, when a professional artist begins
to work up a piece of art from a thumbnail,
he or she will either enlarge the thumbnail
using a photocopier or by scanning it,
opening it on a computer and increasing
its size there. However, if you do not have
access to these facilities then it is best to
redraw the image from scratch at the correct
size. Drawing a faint centreline on both the
thumbnail image and the larger piece of
paper will help you balance your layout.

 Start by loosely sketching the body, the
stance of the pirate and the flow of the
tentacles around him. Notice how the two
largest tentacles are framing the character;
this is a method used by many artists to
draw attention to the main point of interest.
Also roughly sketch out a pile of skulls at the
pirate's feet.

STEP 2

The next step is to sketch
out the clothing. It may
be a good idea to search
the Internet to see what
reference material you
can find, or maybe watch
a few pirate movies.
You can also find lots of
scenes from movies on
the Internet.

STEP 3
Now you can start to develop the details of the clothing and weapons and begin to draw the face.

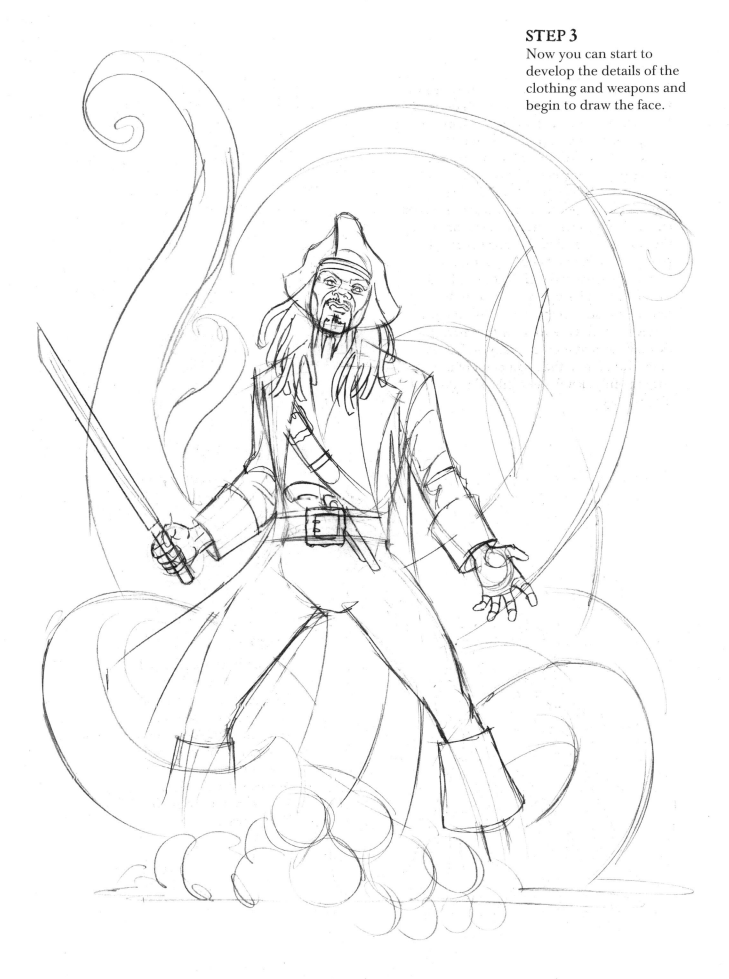

ADDING DETAIL TO THE TENTACLES AND SKULLS

Tentacles

To draw convincing tentacles it will be helpful to study some reference material, such as this picture of an octopus (Figure 6). Notice that the tentacles have two rows of suction cups and that they are not all perfectly aligned. The drawing will look more interesting if the suction cups are a bit irregular and point off in different directions, but make sure that they fit with the curves and twists of the tentacle (Figure 7).

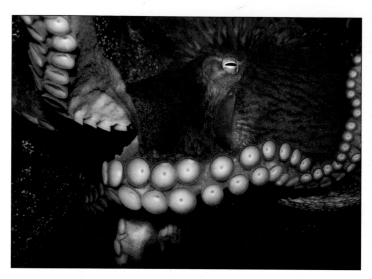

Figure 6

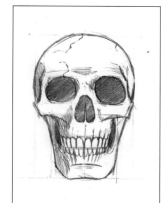

Figure 7

Skulls

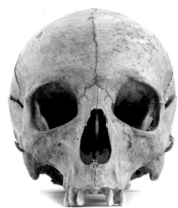

Study the photo of the skull (Figure 8) and you will notice there are curves and recesses around the eye sockets and also around the cheekbones. These shapes will differ from skull to skull so you do not have to be too accurate. Most adults have roughly 14–15 teeth on each row, but this varies and, when drawing a skull from the front, remember that the back teeth are not visible. When drawing an ancient-looking skull, removing some of the teeth gives the skull a more weathered look.

Drawing skulls is similar to drawing a face, but a bit easier, and it is best to start by practising a few on a separate piece of paper. First, draw a circle, then divide it into quarters and draw a square roughly below the centre line (Figure 9). Now add the eye sockets and a hole for the nose, and indicate the position of the mouth (Figure 10). The eyes are basically irregular-shaped circles. Try not to make them too perfectly round – notice there are flat parts too. The nose is like a triangle with rounded edges. Add the teeth (Figure 11), then shade in the eye sockets and nose (Figure 12).

Figure 8

Figure 9

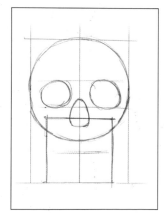

Figure 10

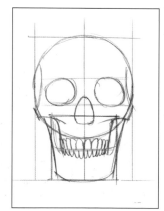

Figure 11

Figure 12

STEP 4

Once you are happy you can draw a skull,
add the details to the pile of them at the
pirate's feet. Aim to draw the skulls in an
irregular arrangement, overlapping and
placed at different angles.

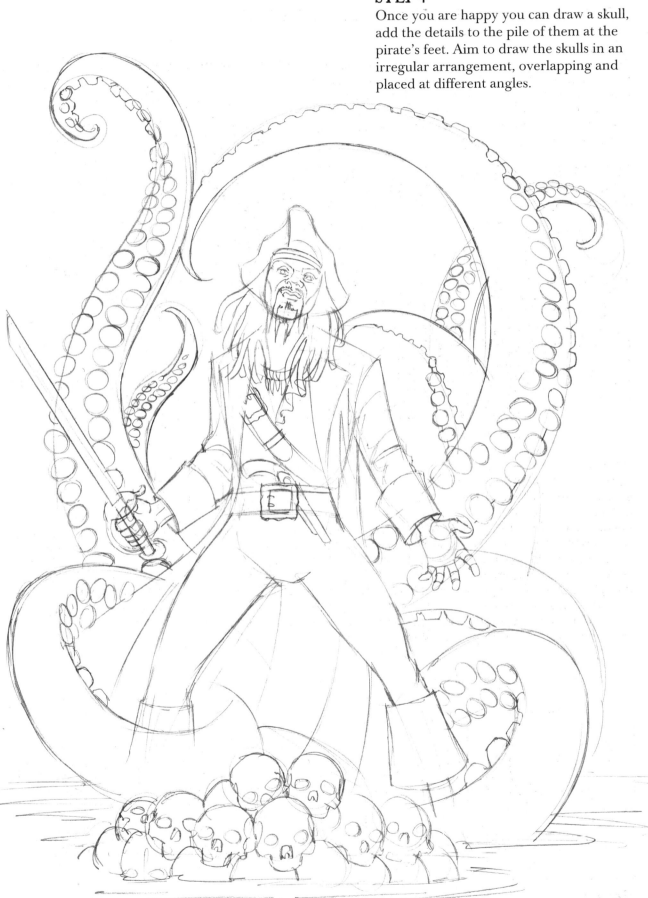

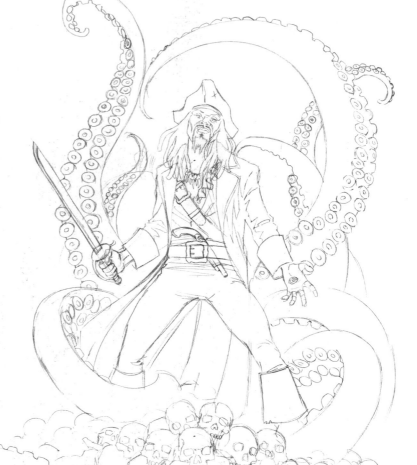

STEP 5

Add the final details to the tentacles, paying attention to the suction cups and making sure that they do not look too aligned and symmetrical – they should look natural. The details on the skulls should also vary slightly so that they do not all look the same. One of the keys to creating convincing artwork is to make it appear as natural as possible. The more mechanical and precise it seems, the less realistic it looks (unless you happen to be drawing machinery, in which case, be precise).

STEP 6

You can now begin the shading. I started by shading the main areas in shadow, such as the folds of the clothing and the underside of the tentacles, as well as the hair, which is not in shadow but which I wanted to be a mass of black.

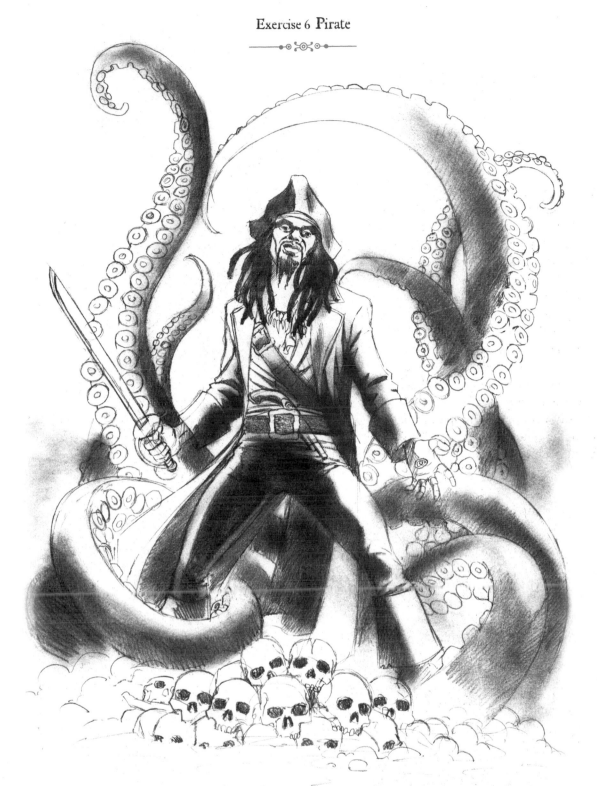

STEP 7

Blend the pencil work to create a smoother finish, and begin to add the mid range tones to the clothing and tentacles using a blending stump or tissue paper (Figure 13).

Figure 13

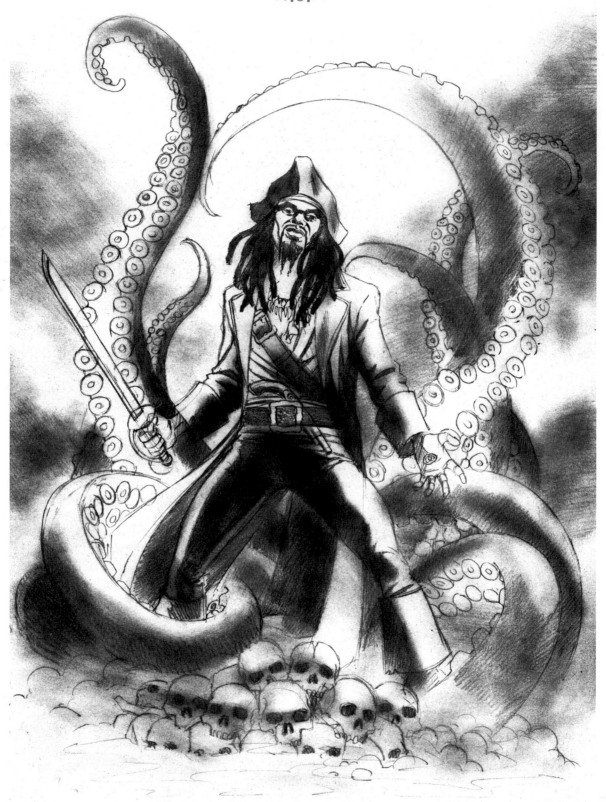

STEP 8

For the background I wanted to create ambiguous cloudy shapes that could either be sky or steam, like clouds of mist rising from the water and around the tentacles. Use an HB pencil to create some cloud-like shapes and blend them together with your finger, using circular motions. Add some extra layers of pencil in places and blend these to create the effect of moving clouds of mist. I found using a piece of tissue worked better than a blending stump.

Add some tonal shading to the skulls and blend it to create an overall tone, so you can create highlights with an eraser later on.

STEP 9
Create the skin detail on the tentacles by blending layers of pencil, then apply fine line work over the top, drawing tightly grouped squiggles and swirls (Figures 14 and 15).

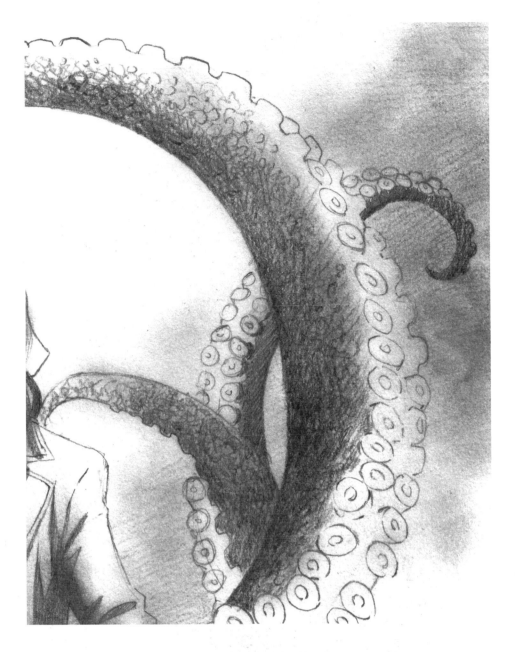

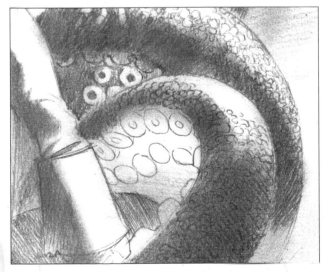

Figure 14

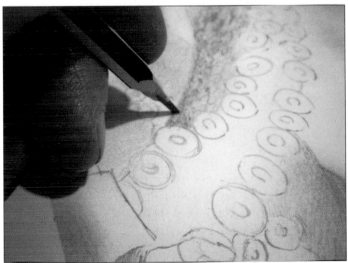

Figure 15

STEP 10

Having added detail to the outer skin of the tentacles, the underside now needs to be developed. This can be done by drawing irregular lines across the width between and around the suction cups, using the flat edge of a pencil (Figure 16).

Sourcing some photos of water ripples (Figures 17 and 18) will enable you to create the water effect shown in the drawing opposite.

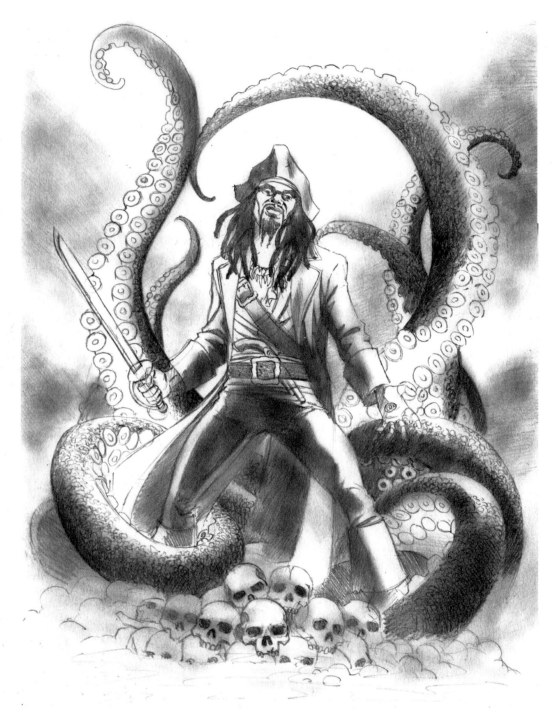

Figure 16

Figure 17

Figure 18

Here you can see that the drawing is almost finished. All it needs now are highlights and some swirling mist.

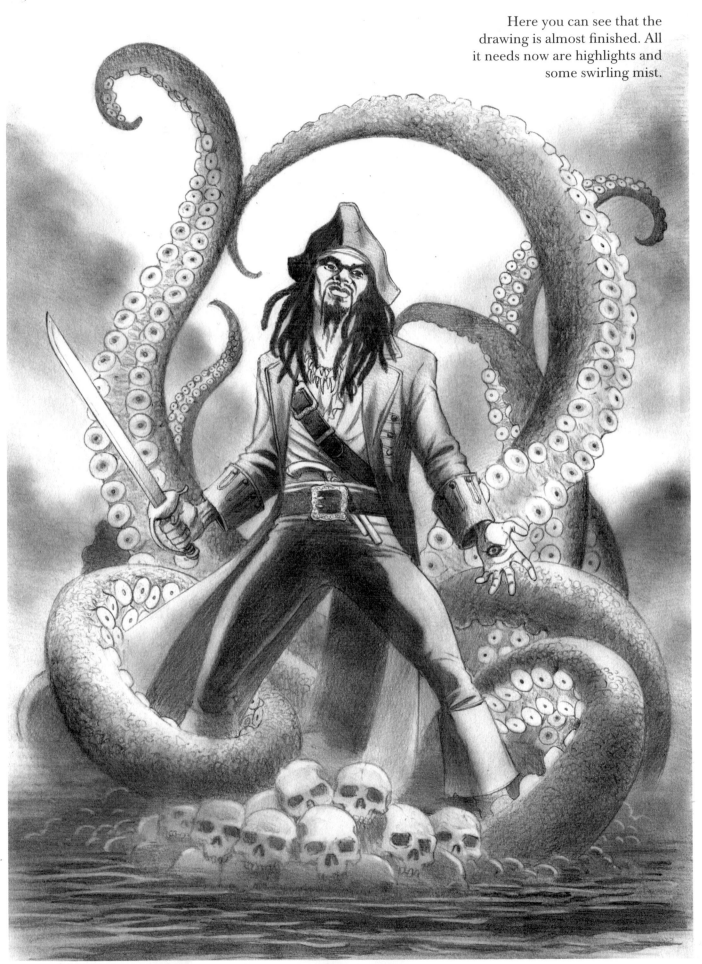

STEP 11

Before creating the swirling mist you should apply highlights to all areas that are looking a bit flat and need emphasizing. Use an eraser to add them to the right-hand side of each skull, and add some mottled highlights to the curves of the tentacles and some of the suction cups.

Figure 19

STEP 12

Some additional darker pencil work can be used to strengthen the ripples before highlights are added with an eraser (Figure 19).

STEP 13

Leave the mist until last, so that it is applied over the highlights, to create a more believable effect. I achieved this by dragging a stump of a well-worn eraser over the skulls, around the tentacles and behind and in front of the legs. Finally, if there are any parts of the drawing that need defining, apply a crisp pencil line with an HB pencil. You can see the completed drawing on the facing page.

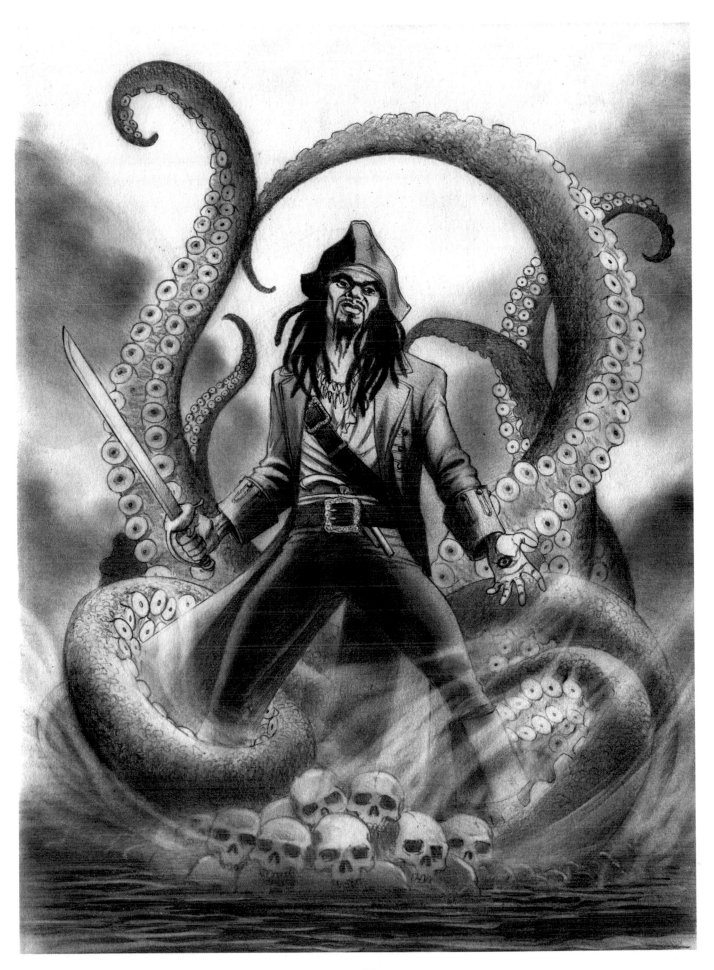

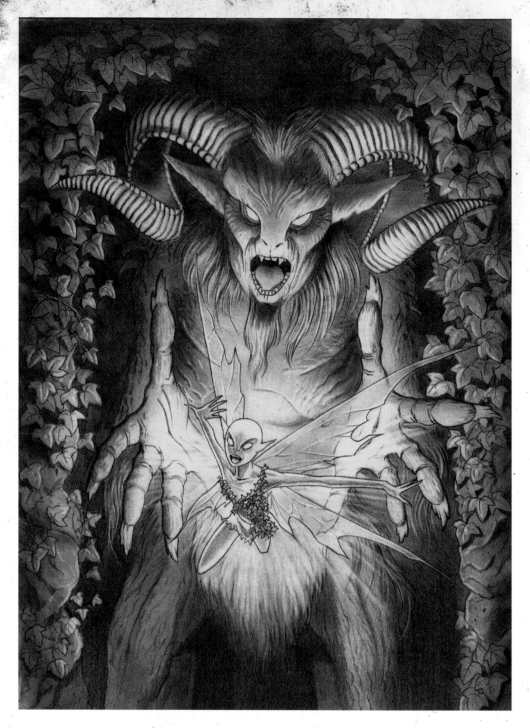

EXERCISE 7

THE ENCHANTED

(More Complex Exercise)

I was inspired by Guillermo del Toro's film *Pan's Labyrinth* when I was drawing this image, although there are some differences between the faun and fairies in the movie and the ones in this exercise. I didn't want to draw an exact re-creation of the characters in the film, so I purposely relied solely on my memory rather than looking at clips. Fantasy films are often a rich source of inspiration, and this drawing pays homage to del Toro's beautiful work.

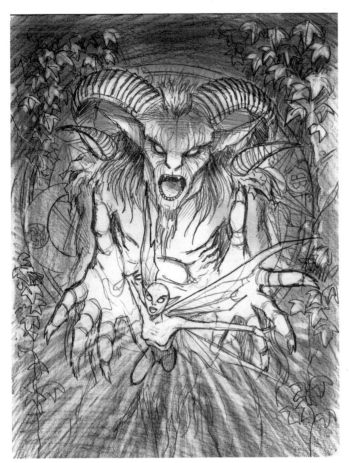

Figure 1

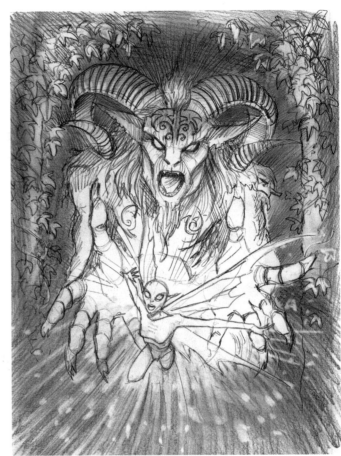

Figure 2

I started by creating some rough thumbnail sketches exploring variations on a theme. In Figure 1, I included a magic symbol behind the faun, which framed the subject. Initially I liked this approach, but then I thought it was too contrived, so I placed the faun and the fairy in an archway covered in ivy (Figure 2). I preferred the uncluttered layout and decided to use this arrangement.

Figure 3

Figure 4

Fauns are generally depicted as half human and half goat. As usual, you need to source some reference material, such as a photo of a sheep or goat (Figure 3) and some horns (Figure 4), so you can get a feel for the shape and detail of the objects. Having studied real objects you can then adapt them for fantasy art using a bit of artistic licence.

Before I began the final piece of artwork, I wanted to make sure that I was happy with the faces of the faun and the fairy. Although I liked the middle and bottom sketches of the faun (Figure 6 and Figure 7), I felt they looked a bit too evil, so I decided to use the top sketch (Figure 5).

I also explored a variety of ideas for the design of the fairy (Figure 8) before deciding on the final design. I chose Figure 9.

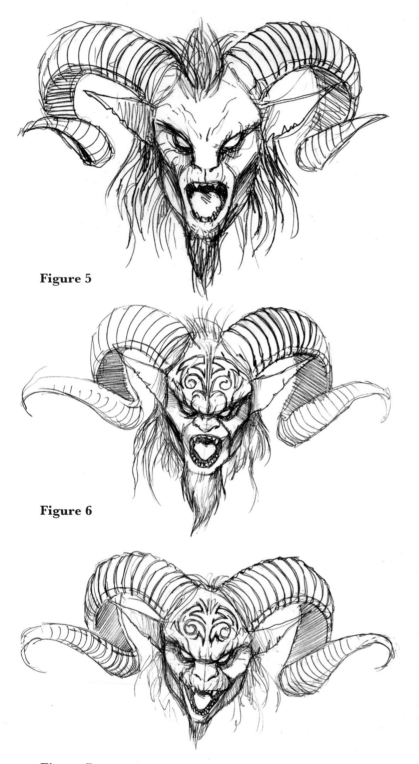

Figure 5

Figure 6

Figure 7

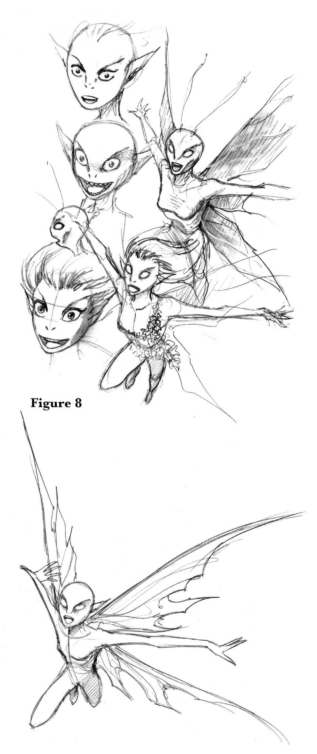

Figure 8

Figure 9

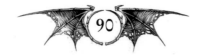

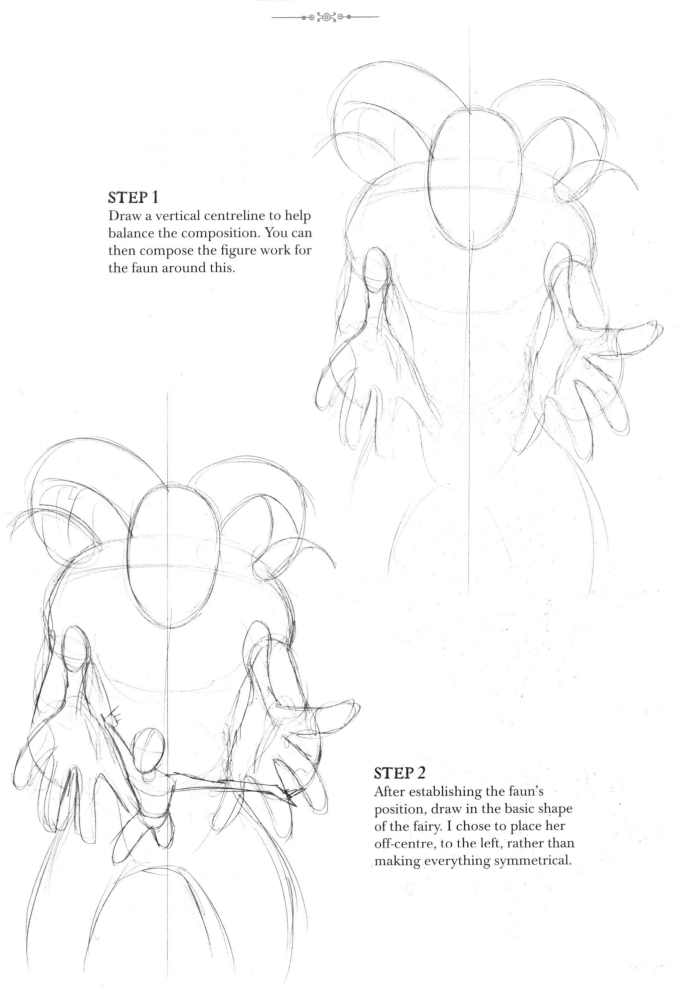

STEP 1

Draw a vertical centreline to help balance the composition. You can then compose the figure work for the faun around this.

STEP 2

After establishing the faun's position, draw in the basic shape of the fairy. I chose to place her off-centre, to the left, rather than making everything symmetrical.

STEP 3

Once you have established the positions of the figures, focus on the outer surrounding detail, which in this case will be a stone arch covered in ivy. I was familiar enough with ivy to be able to draw a believable representation, but it helps to have a visual reference (Figure 10). This shows that an ivy leaf consists of three or five points, and some appear to be almost triangular, so a mixture of all three leaf shapes would create authentic foliage.

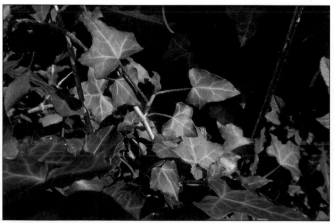

Figure 10

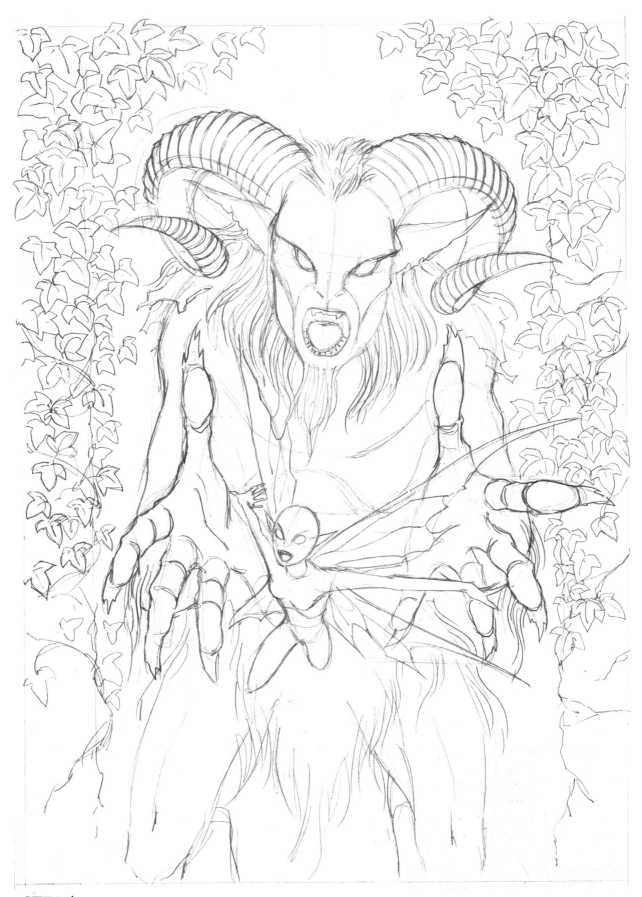

STEP 4
Keep the leaf shapes simple and gradually cover the stone pillars,
trying to make the foliage appear to grow naturally upwards.

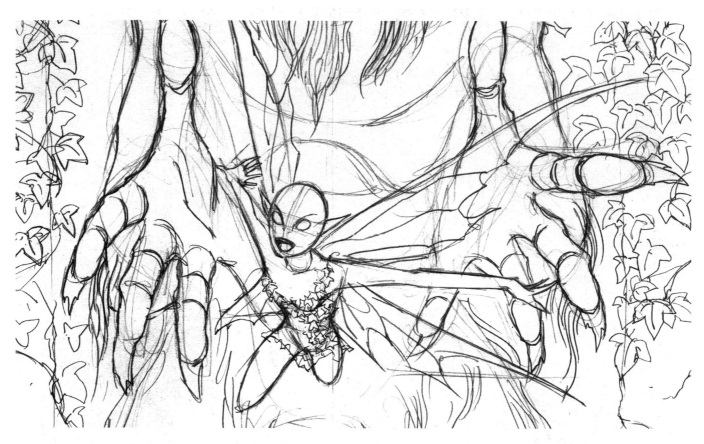

STEP 5

You can now consider the characters'
costumes. Rather than leaving the fairy
naked, I thought it might be nice to continue
the ivy theme and create a kind of short ivy
dress. The leaves here are a lot smaller than
those climbing the stone archway.

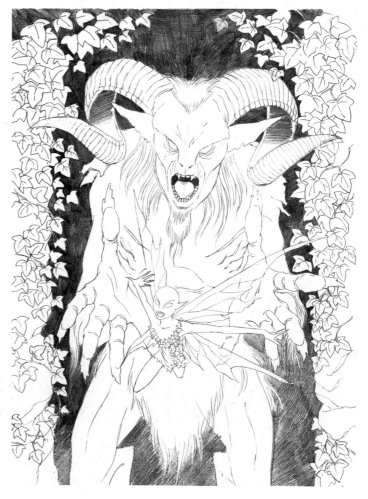

STEP 6

Once all the line work has been
established, add shading to the
background with a B pencil. I
used an HB towards the bottom
of the page for a lighter tone as
I knew I would be erasing some
of it to form highlights, and it is
easier to erase HB lead.

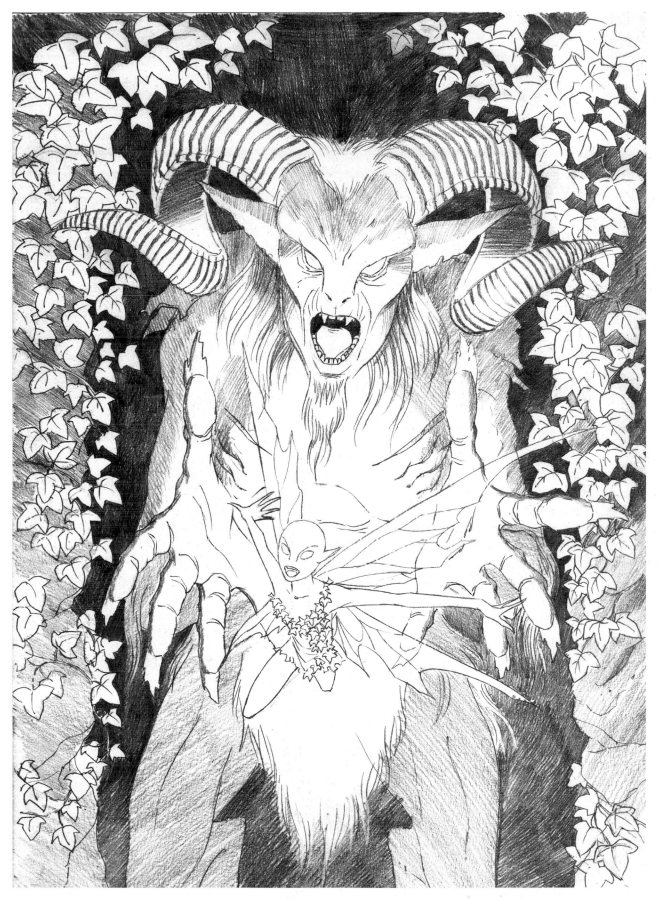

STEP 7

You can now apply mid-range tones to the stone wall,
the faun's legs and the outer edges of the arms.

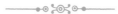

STEP 9

You can now carefully blend the shaded areas of the faun. You may prefer to use a blending stump for the smaller areas.

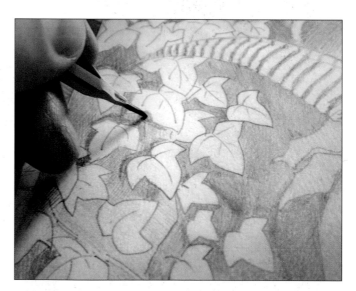

STEP 8

Using a blending stump or tissue paper, blend the mid-range pencil work. I purposely went over the ivy while blending to give the leaves some tone. I find this is achieved more successfully using tissue paper rather than a blending stump, though you may prefer the effect provided by the stump. Leave plenty of light around the central area where the fairy is positioned, as this will be the main light source.

STEP 10

Apply a dark shadow to the ivy. The shadow would be cast by the central light source, so the direction of the shadow will change depending on where the ivy is in relation to the light. The ivy leaves at the top left of the page will cast a shadow to the far top left, whereas those at the bottom left will cast a shadow to the far bottom left.

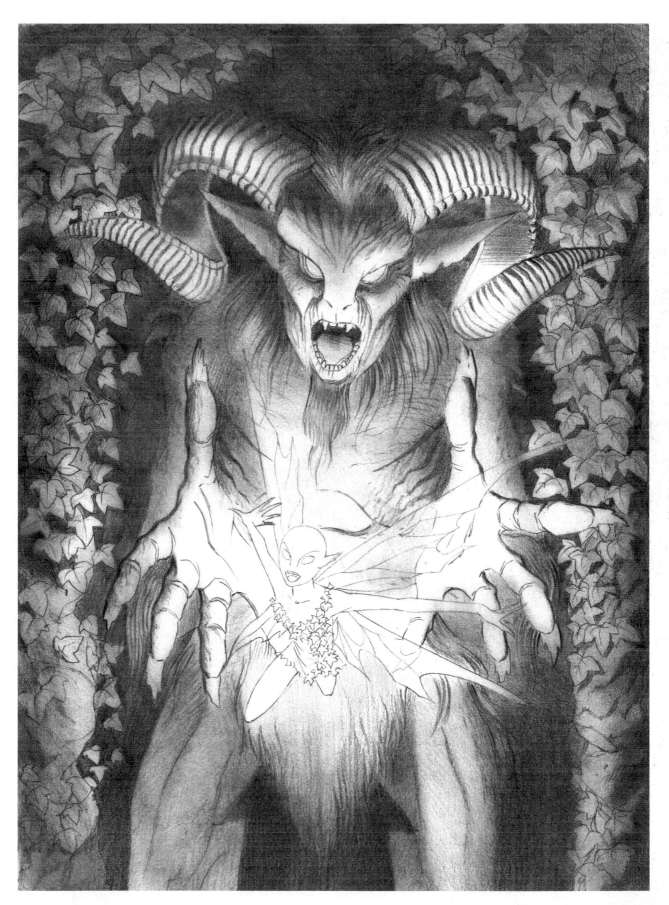

STEP 11

Here you can see that the shadow lifts the ivy away from the stone.
You should check the shading at this stage, before adding highlights.

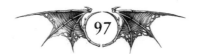

STEP 12

It is now time to apply highlights to the areas that are nearest the light source, including the
faun's face, hair (Figure 11) and hands; the ivy nearest the light source (Figure 12); and the veins
in the fairy's wings. This not only brightens up the drawing but also creates a sense of depth.

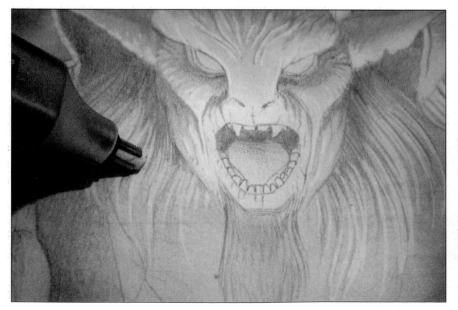

Figure 11

Figure 12

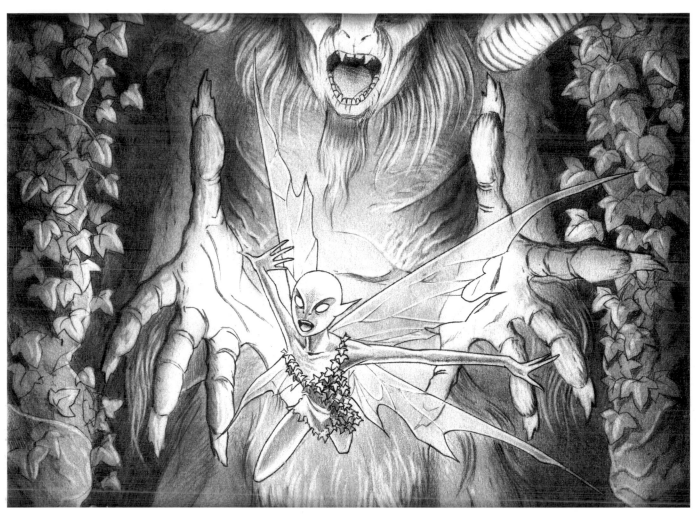

STEP 13

After applying the highlights, the drawing needs to be tidied up. Draw a thin, crisp line around the body of the faun and the fairy (Figure 13), paying particular attention to the wings (Figure 14). Notice how the thin line work adds strength and clarity to the drawing.

Figure 13

Figure 14

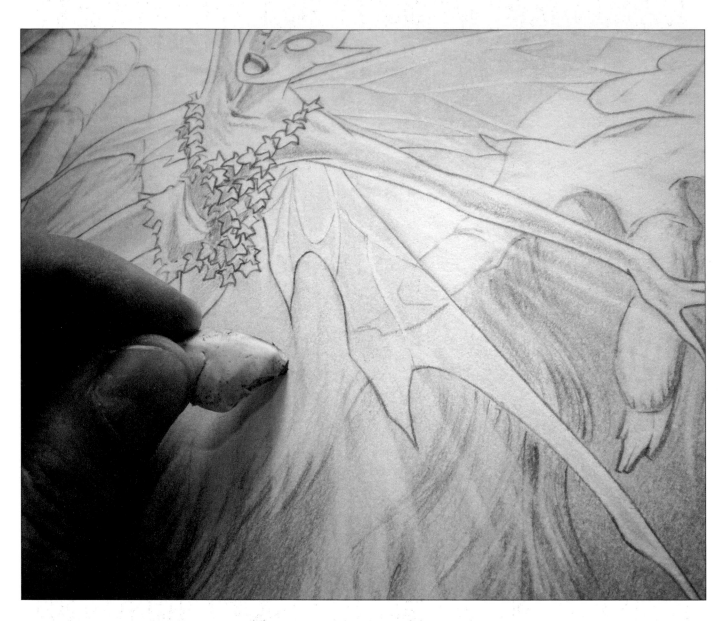

STEP 14

The final step is to add rays of light shooting from between the hands of the faun, creating a fantastical light source for the image. This was achieved using the round-edged stump of a plastic eraser. A putty rubber can also be used.

The final drawing can be seen on the opposite page.

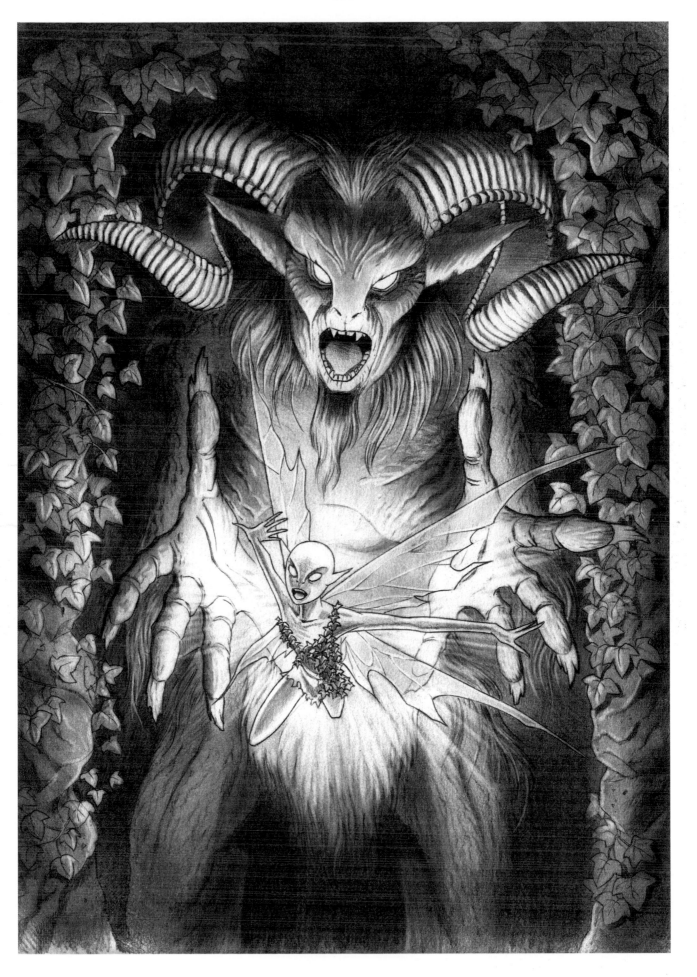

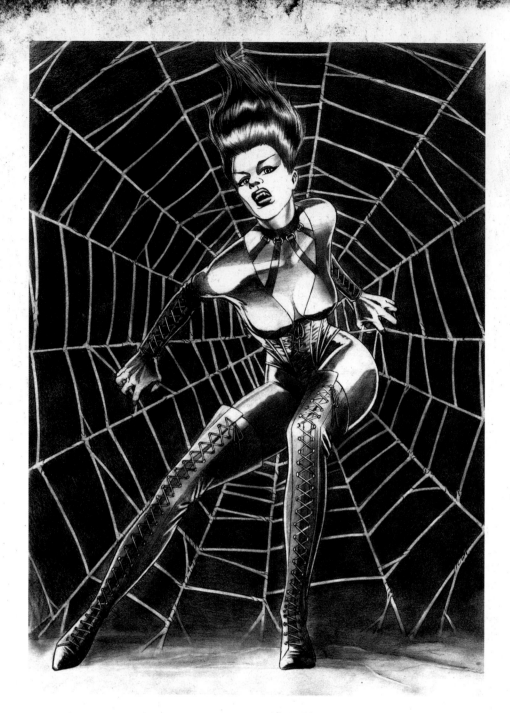

EXERCISE 8

—◦ ⚬❧⚬ ◦—

BLACK WIDOW

—◦ ⚬❧⚬ ◦—

(More Complex Exercise)

This drawing was inspired by James Whale's 1935 horror movie *Bride of Frankenstein*, and 1950s sci-fi movies and glamour pin-ups. Just as with Exercises 2 and 4, the objective is to turn what would normally be considered a repulsive creature into something strangely attractive.

The female black widow spider is the most poisonous spider in North America and is recognizable by the hourglass shape underneath the abdomen. The body is shiny and black. In this drawing the corset represents the hourglass shape, the PVC clothing mimics the shiny coating of the spider and the fangs make the character appear predatory.

As usual, I produced a set of rough thumbnail sketches to arrive at the desired composition (Figure 1).

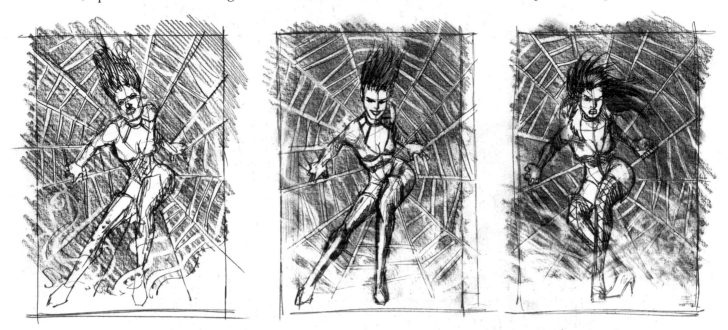

Figure 1

STEP 1

Lightly sketch the figure, paying attention to the balance of the pose. Most of her bodyweight is on her left leg (her right as we are looking at her) and the right leg is positioned to balance her. Notice the position of her upper body and how it is situated above the legs.

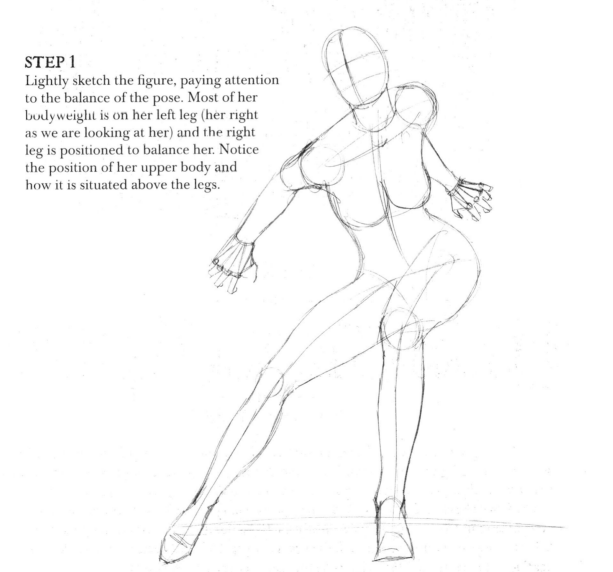

STEP 2

Roughly sketch in the web strands. Notice how the strands stem from the centre of the picture, behind the figure. This will act as a visual aid and will draw attention to the character, while the outline of the web forms a circle that frames the whole picture. You can also now draw the face and hair. Here, the head is tilted back slightly but her eyes are looking directly at you. The hairstyle is a reference to Elsa Lanchester as the *Bride of Frankenstein*.

STEP 3

The clothing can now be sketched out. The style of clothing I chose is gothic dominatrix. Reference for this type of clothing can be found in gothic clothing catalogues, which are available online, as well as on the high street. Movies such as Len Wiseman's vampire trilogy *Underworld* are another good point of reference.

STEP 4

The finer details of the
clothing can now be added.
The intricacy of the lacing
of the boots and corset
are intended to continue
the web theme. The straps
attached to the dog collar/
choker also stem outwards
like the webbing.

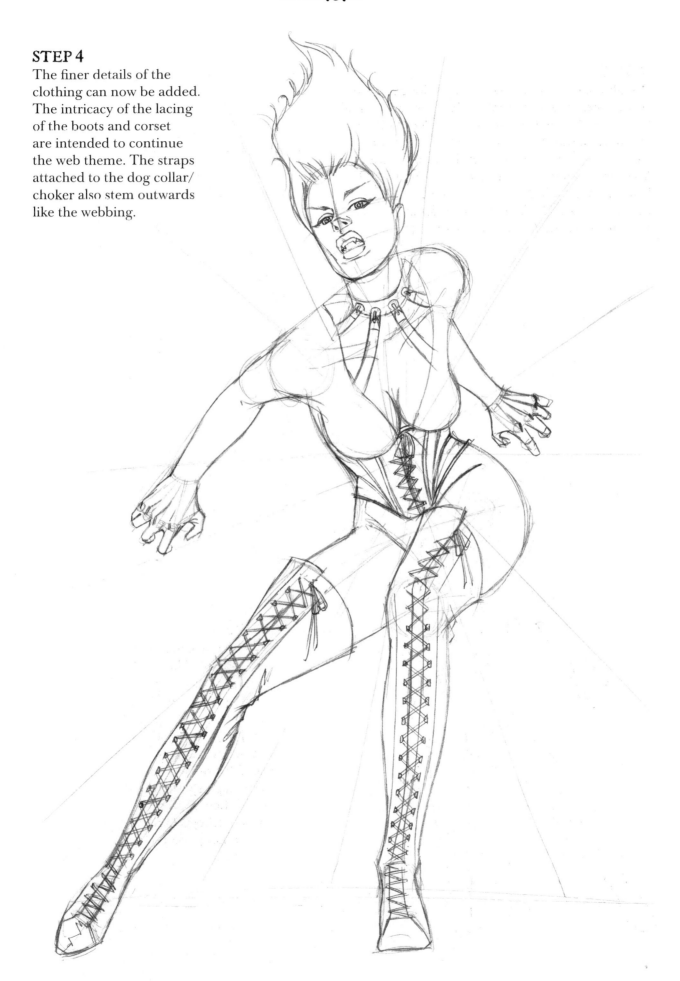

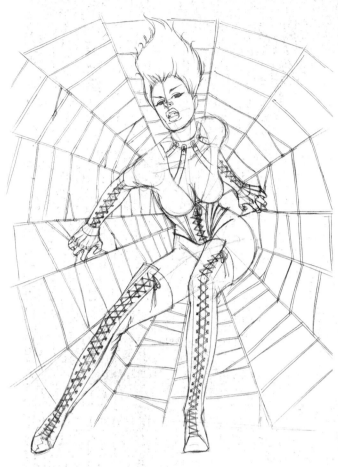

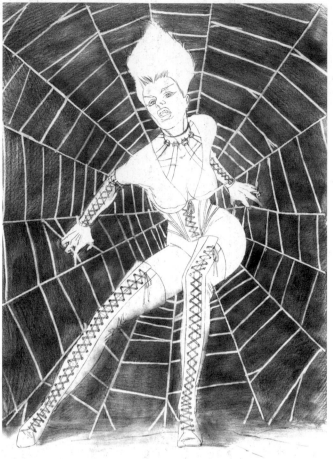

STEP 5

Add more detail to define the webbing. Keep the strands fine; the web should look delicate yet strong.

STEP 6

I decided on a simple, dark background tone to help isolate and strengthen the delicate strands of the web. I used an HB pencil and gently blended it with tissue paper, going over parts of the web to give the strands a very light tone. I carefully applied a further darker tone to the background, between the strands of the web, and this time blended with a blending stump so I could be more precise.

STEP 7

Shade the PVC clothing with a dark tone using an HB pencil, leaving white highlighted areas, then blend the shaded areas with a blending stump. Study the photo reference (Figure 2) for guidance. You can accentuate the web by going over the strands of the webbing with a Derwent battery-operated eraser, which gives a good, clean line.

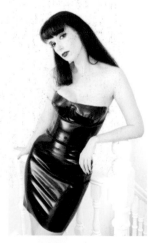

Figure 2

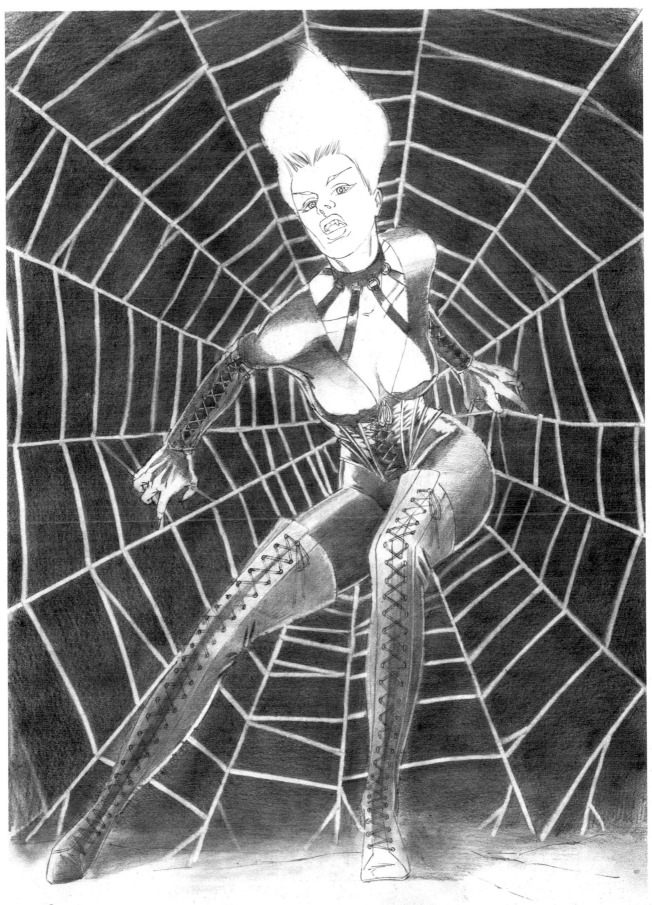

STEP 8
Sit back and observe the overall effect.
Add any extra shading or highlights as required.

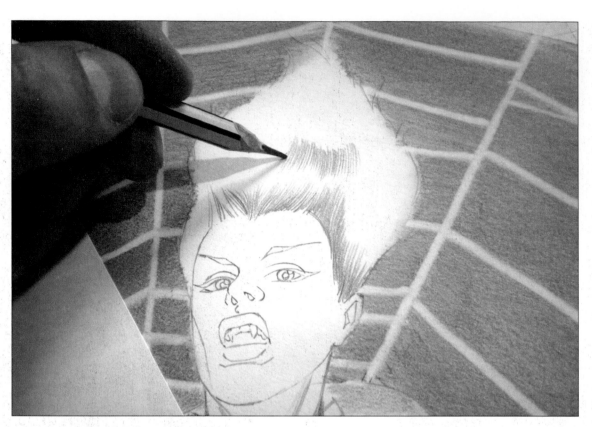

STEP 9

You can now add details and shading to the face and the hair. I decided to match the sheen of her lips and hair with the sheen of her clothing, emulating the overall glossiness of the black widow spider. The face has been created using hard contrasts. There are hardly any subtle tones present, apart from around the eyes and on the left-hand side of her face (as we are looking at her), which is in shadow.

The hair was created using an HB pencil, applying varying pressures to create light and dark tones.

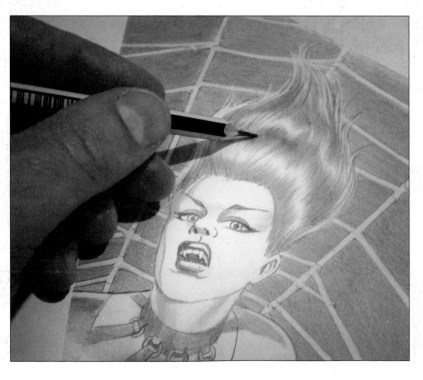

STEP 10

Use a blending stump to blend the highlights, then follow with a few more defining strokes with an HB pencil to create hair strand detail. You can see the completed head on the opposite page: notice how the inside of the mouth is completely black, to highlight the white fangs (canines).

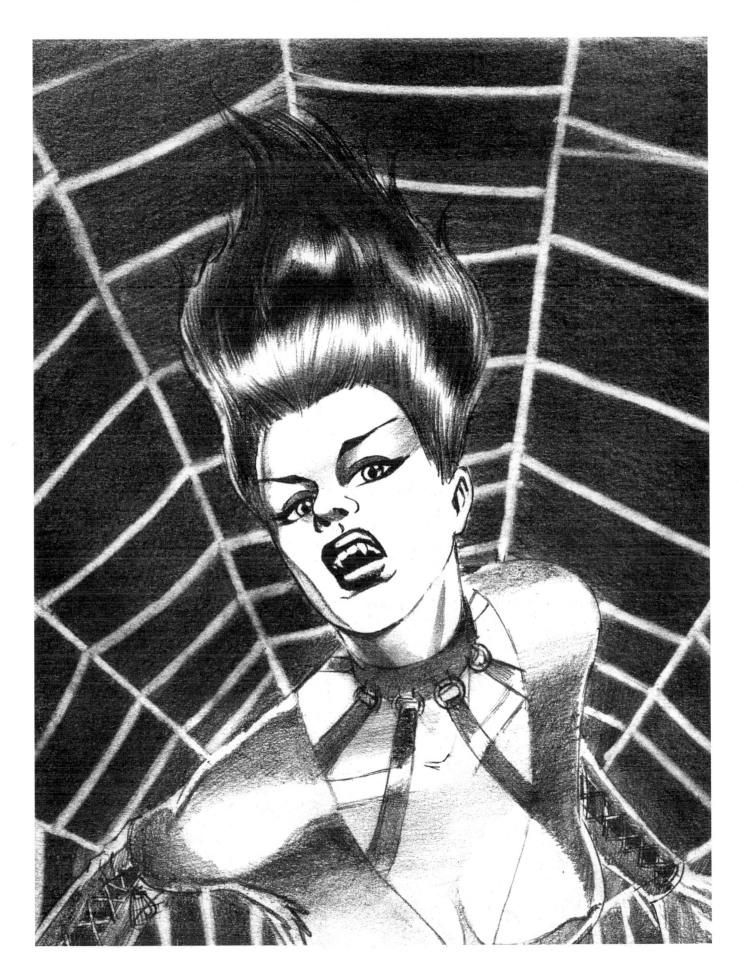

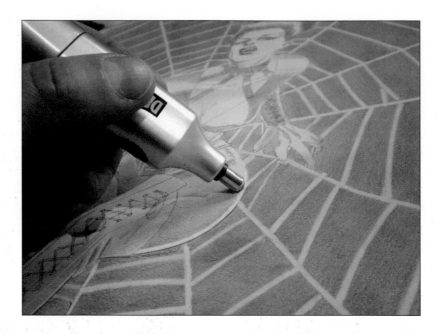

STEP 11

When all the shading and tone work is finished, you can add hard, fine highlights to the outer areas of the figure to lift her away from the dark background. The best way to do this is to use a finely chiselled eraser and the finely moulded point of a putty rubber or, as shown in the photograph, the edge of a battery-operated eraser where the eraser has been cut to form a sharp edge.

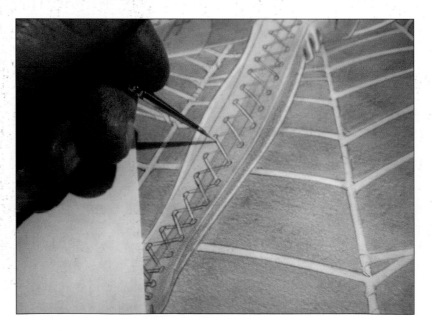

STEP 12

Once the highlights have been applied, go over the drawing with an HB pencil, drawing a fine, crisp line around the entire figure. This helps to accentuate the highlights and also lifts the figure away from the background.

STEP 13

You may want to pick out the detail of the lacing on the boots and corset. An eraser will not be suitable for highlighting this level of fine detail, but you can paint in the highlights with permanent white gouache using a No. 0 brush. On the opposite page you can see the final image, which I converted to a sepia tone using Photoshop.

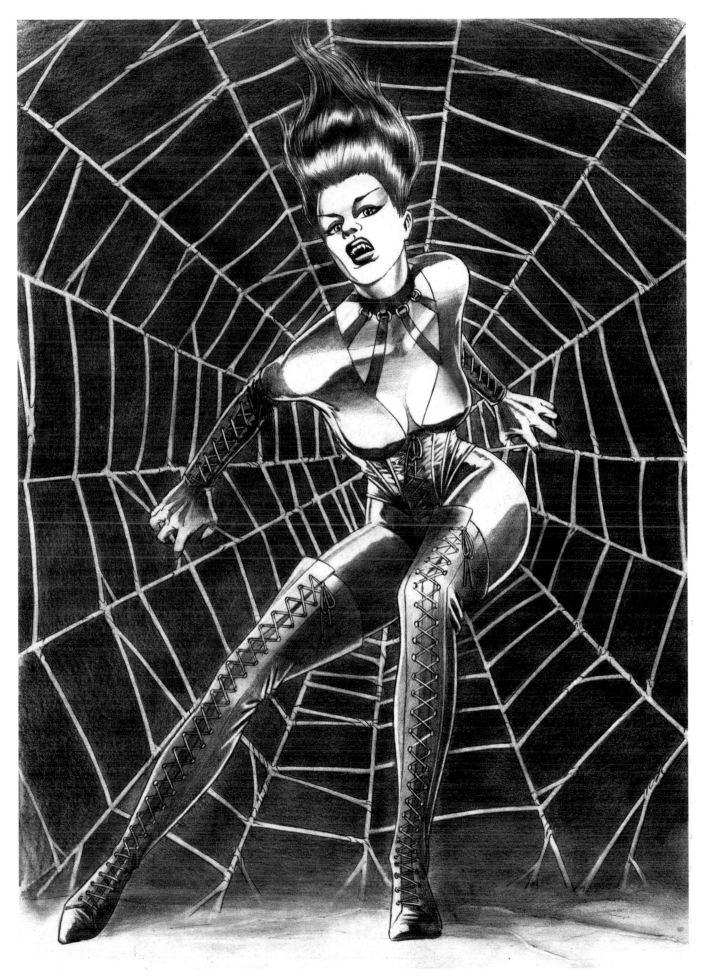

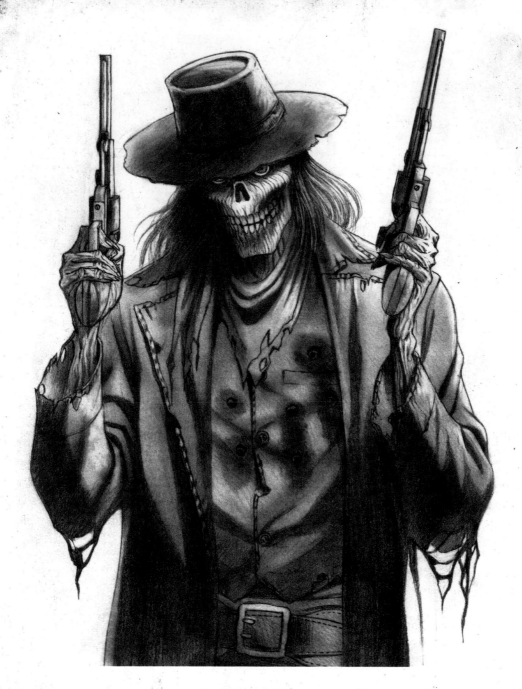

GUNSLINGER

(More Complex Exercise)

I'm a big fan of both westerns and Sam Raimi's movies. Sam Raimi has made movies about the undead (*The Evil Dead* trilogy) and about gunslingers (*The Quick and the Dead*) but, to my knowledge, he has never mixed the two genres. I thought it would be interesting to combine the undead and gunslinger themes and create an *Evil Dead*-style cowboy, back from the grave to seek vengeance.

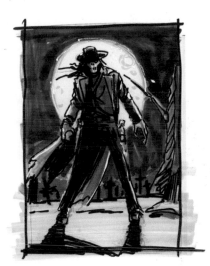

Figure 1

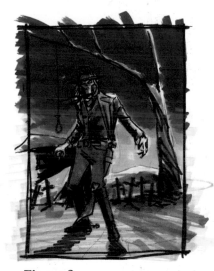

Figure 2

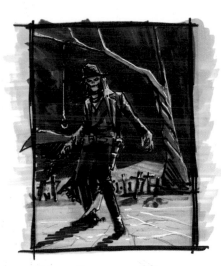

Figure 3

While producing the thumbnails for this picture, I considered a few wide shots showing a full pose (Figure 1, Figure 2 and Figure 3), and I thought about whether to colour it or not. In the end I decided to go for a close-up black and white image (Figure 4) as I thought it would be more fun developing the face than drawing a distant, less detailed view.

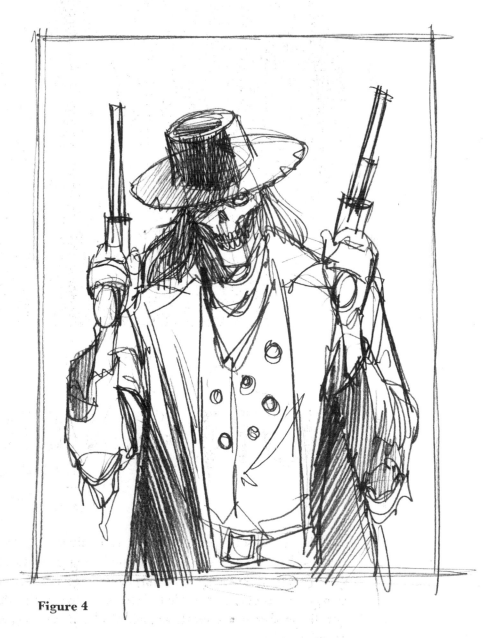

Figure 4

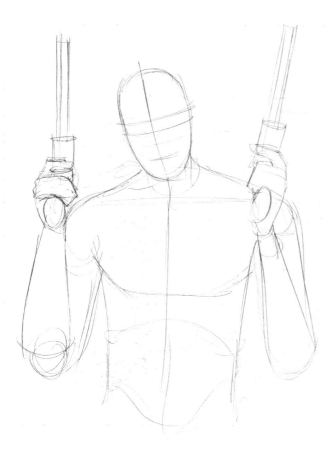

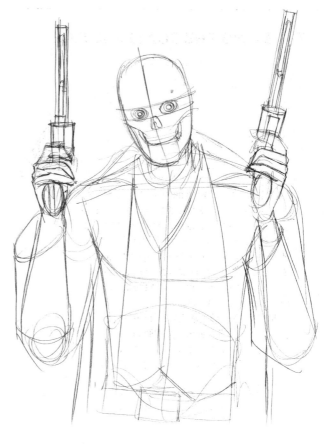

STEP 1

Map out the figure in rough. You may not need to start with a skeletal figure for this exercise – just gauge the proportions of the arms in relation to the torso. Mark out the dividing lines for the face, which will help you place the eyes, nose and mouth correctly.

STEP 2

Map out the clothing and the skull. When drawing the skull, refer back to page 78 or use the photo reference below (Figure 5), although in the drawing the skull will have withered skin stretched over it. The clothing is based on the long coats worn in movies such as *Once Upon a Time In the West*, *The Good, The Bad, and The Ugly* and *Long Riders* (Figure 6).

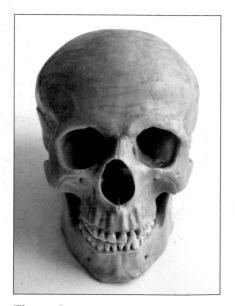

Figure 5

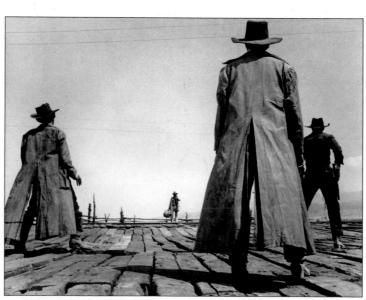

Figure 6

DRAWING THE GUN: PRACTICE

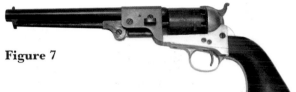

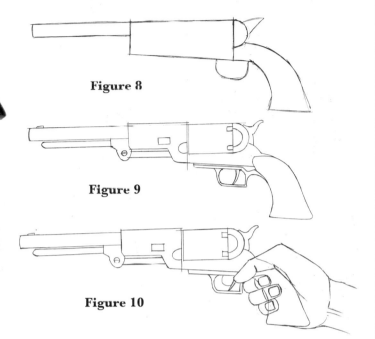

Figure 7

To draw guns successfully it is best to do some research first. Handguns come in all shapes and sizes, from revolvers to automatics, and each has its own characteristics. The gun in this drawing is a Colt Model 1848 Percussion Revolver (Figure 7). As with drawing anything for the first time, I recommend breaking the object down into manageable shapes. This helps you become familiar with the item, making it easier to draw it well.

First establish the basic shape (Figure 8), then add a little more detail to the gun (Figure 9).

Once you are happy with the gun, work out how the hand fits around the handle and trigger (Figure 10).

Figure 8

Figure 9

Figure 10

STEP 3

Once you are familiar with the shape of the gun, go through the stages again with the gun shown in the correct position for the final drawing. Start with the basic shape, then add the leading lever and cylinder pin. Draw in the shape of the hand as it holds the gun, then refine and develop it and add the nails.

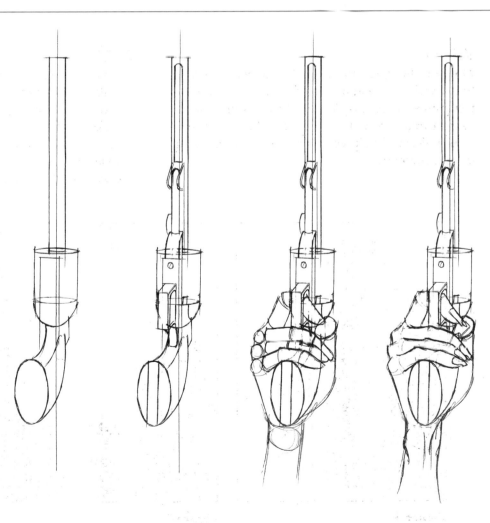

STEP 4

Sketch out the position of the hat, using reference material for a guide to its look (Figure 11), and work out how it sits on the head. Incorrect positioning can look awkward and lopsided, so it is good practice to draw the head and hat as transparent shapes, which can easily be deleted, to get the correct fit. The clothes can also now be developed further.

Figure 11

STEP 5

Remove any development sketch lines with an eraser. Do not worry about making the drawing too clean, as most of the line work will be covered by the shading. Define the features with clean line work, making sure all the details are present for the face, clothing and guns before you commence on the shading.

STEP 6

The first stage of shading is to identify the main solid areas of shadow created by the light source, which in this instance comes from an area to the figure's right as we are looking at him. Block these in using an HB pencil.

STEP 7

Add the mid-range tones with an HB pencil, then softly blend between the dark and mid-range tones with tissue paper (Figure 12). I also used a blending stump around the face. The bullet holes can be strengthened with darker shading.

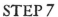

Figure 12

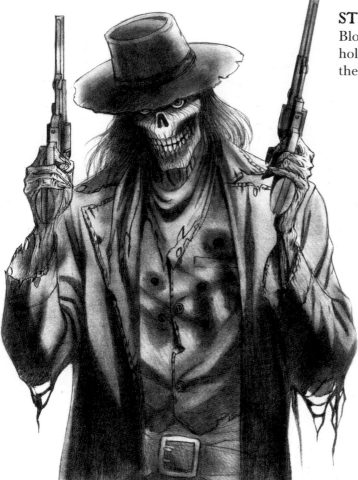

STEP 8

Bloodstains can be created around the bullet holes by adding a heavy tone with a B pencil, then blending with a blending stump.

STEP 9

The withered skin can now be applied to the skull. It needs to look dried, stretched and drained of all fluids. Wrinkles should be added using the fine point of an HB pencil, which can then be blended with a stump before a further layer of fine detail is applied over the top.

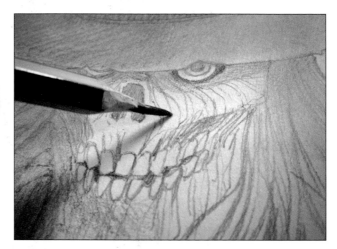

STEP 10

The same process is used for the hands and hair. Using an eraser, create highlights on the hair, face (Figure 13) and hand (Figure 14). Carefully apply a few sparing highlights to the rim of the hat, and to the left edges of the gun barrel, cylinder and trigger guard. Finally, apply a crisp, thin, hard line with a sharp HB pencil to add definition. The completed Gunslinger is on the opposite page.

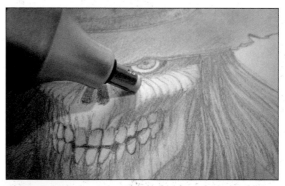

Figure 13

Figure 14

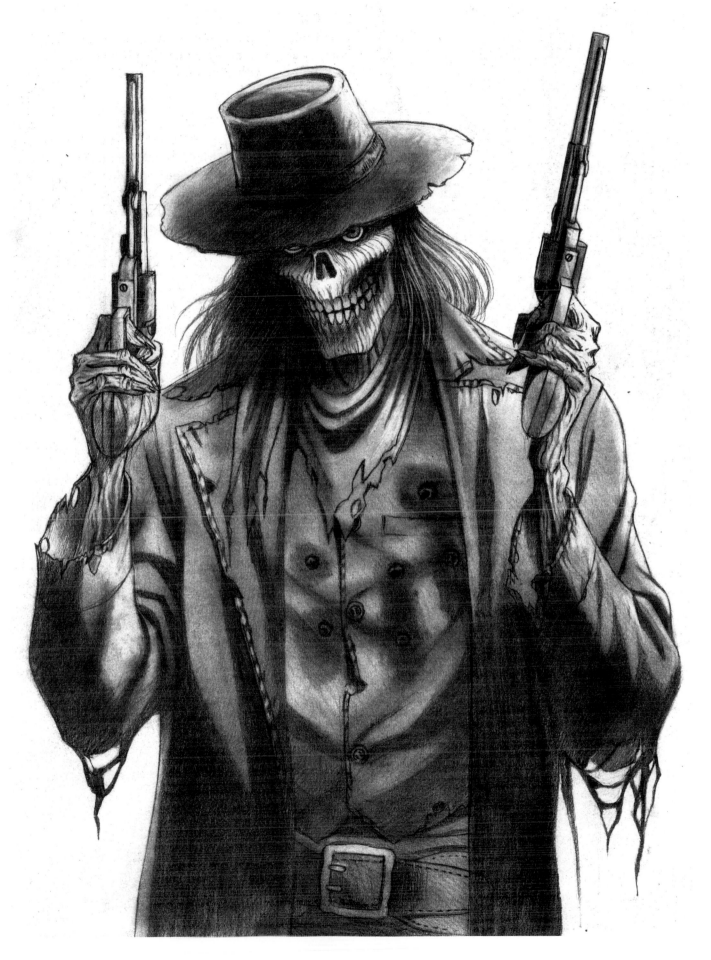

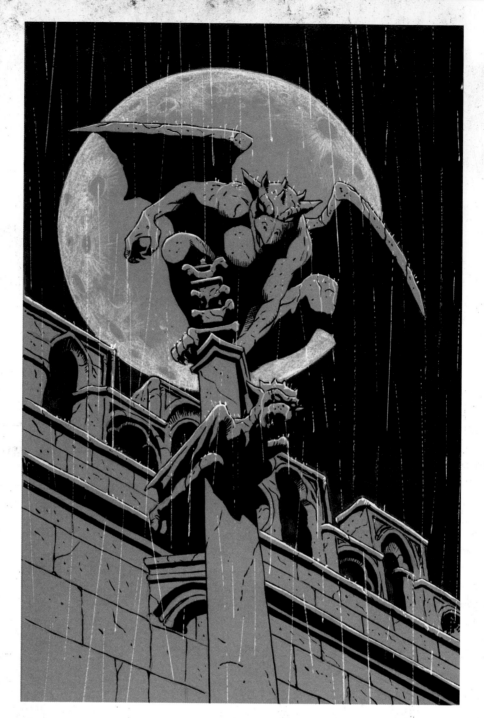

EXERCISE 10

-◦❖◦-

GARGOYLE

-◦❖◦-

(More Complex Exercise)

This last exercise is typical of a quick sketch session, during which I take a class through a sketch from beginning to end in one and a half hours. The purpose of the exercise is to show how easily and effectively a drawing can be achieved in a short space of time. Often these are produced on coloured paper and inked with a Faber-Castell Pitt Artist pen and a coloured marker that complements the choice of paper.

Figure 1

Figure 2

Figure 3

Figure 4

Figure 5

Figure 6

The materials you will need for this exercise are: grey or stone coloured paper (Figure 1); permanent white gouache (Figure 2); No. 0 or No. 2 watercolour brush (Figure 3) or a Pentel correction pen (Figure 4); Faber-Castell Pitt Artist pen (Figure 5); B26 Cobalt Blue or a B29 Ultramarine Copic marker (Figure 6).

To get a feel for the look of the gargoyle, source some photo reference, as shown in Figure 7 and Figure 8. On my travels, I often take photographs of any architecture that I think is interesting or that will possibly come in useful for reference on a future project. For this drawing, I used photographs of St Martin's Church on Coney Street in York (England) (Figure 9 and Figure 10).

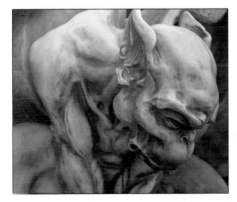

Figure 7

Figure 8

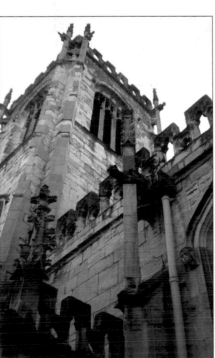

Figure 9

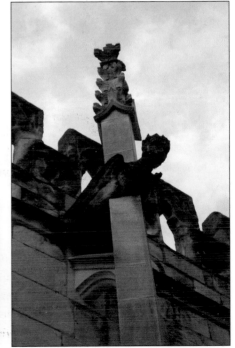

Figure 10

PERSPECTIVE

The main things to consider when working from a photograph are the angles and perspectives inherent in the shot. Some settings can provide striking backdrops for additional imagery that you may wish to superimpose. In this exercise, the Gothic building and upward-looking perspective lend themselves well to a winged figure, and a gargoyle seemed an apt subject.

In order to draw both the setting and the gargoyle correctly you will require some knowledge of perspective drawing, so the aim of this section is to outline the basic rules. Figure 11 shows a railway track disappearing into the distance. Notice how the rails get closer together the further away they are from the foreground. The point at which they meet is called a point of perspective or a vanishing point. The horizontal line that crosses the point of perspective is called the horizon line.

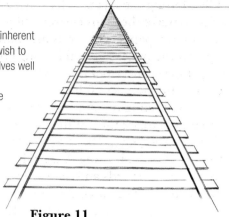

Figure 11

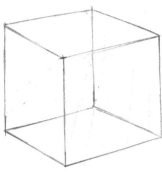

Figure 12

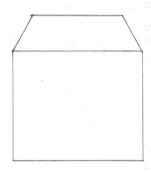

Figure 13

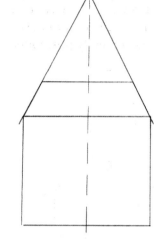

Figure 14

We shall use a basic cube (Figure 12) to show how the rules of perspective work. If we turn the cube so we are looking at it straight on (Figure 13) you will notice that the two sides on the top of the cube appear to draw closer together, or converge, towards the back. If these lines are extended, they will eventually meet (Figure 14). The point at which they meet determines the horizon line. This is called single or one-point perspective because the perspective lines meet at a single point.

When the cube is turned so that the corner point faces the front (Figure 15), we get two-point perspective below the horizon line (eye level). If the viewpoint changes, so does the horizon line (Figure 16).

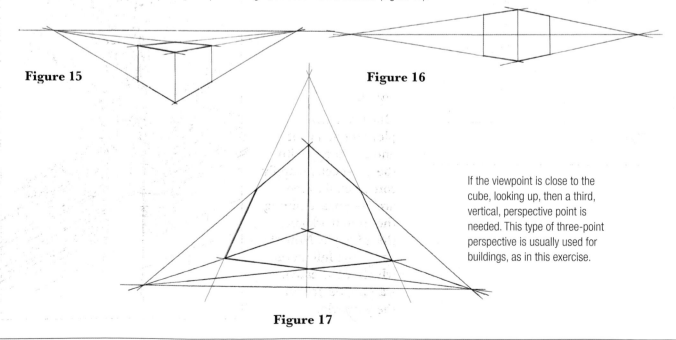

Figure 15

Figure 16

If the viewpoint is close to the cube, looking up, then a third, vertical, perspective point is needed. This type of three-point perspective is usually used for buildings, as in this exercise.

Figure 17

STEP 1

Start by plotting the layout. I have used white paper for this exercise to make the steps clearer, but you can draw directly on to coloured paper. The vanishing points for this drawing go right off the page, so roughly gauge the perspective or (loosely) tape extra paper to the main sheet and work out your vanishing points in full.

Draw a vanishing point above the figure and converge the lines that demarcate the outline of the figure at that point (A). You can then gauge the angle of the castellations on the top of the wall, drawing diagonal downward lines from left to right (B) towards an imagined vanishing point off the paper. To create a three-dimensional effect and give the castellations depth you need to add a further set of diagonal lines travelling in the opposite direction (C) towards another imagined vanishing point off the paper, creating three-point perspective. Figure 18 is a cleaned-up version so that you can see how the different components in the image work once they have been correctly positioned.

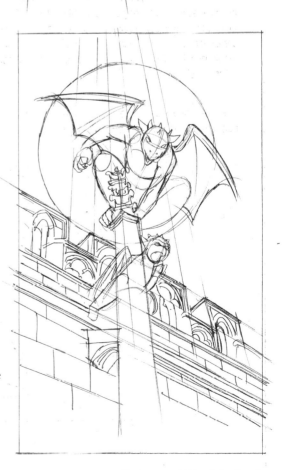

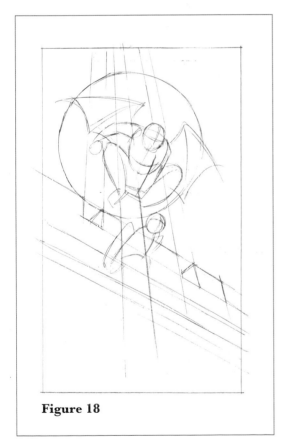

Figure 18

STEP 2

Once you have plotted the layout and are happy with the perspective, apply some detail to the architecture, defining the stonework and the gargoyle. Note the use of the full moon, which will create a framing device for the gargoyle.

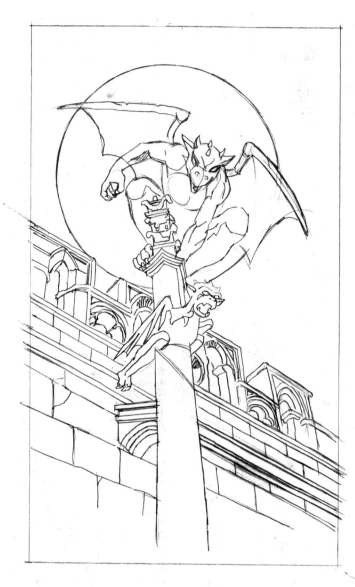

STEP 3
Develop the detail of the gargoyle's character, taking pointers from the photo references you have collated. The face here is almost like that of a small dragon.

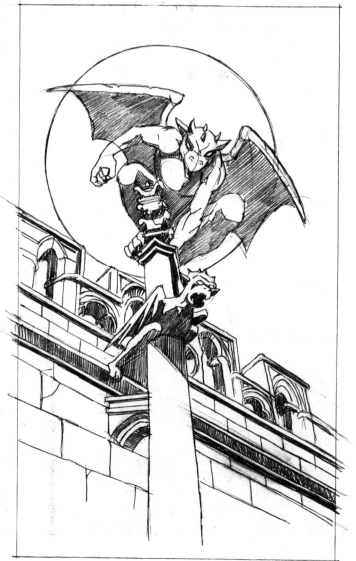

STEP 4
Shading can now be applied to the areas that will be mostly solid black. In reality, if a full moon this size were directly behind the gargoyle you would mostly see a silhouette, so to make the drawing more interesting I have used some artistic licence and inserted some additional off-frame light sources.

STEP 5

Once all the pencil work is complete, apply the ink. I used a brush pen for this drawing as it enabled me to create some bold line work as well as enabling me to pick out delicate lines from the stonework details. First, I went over all the line work with ink, then I filled in the solid areas. I purposely created an uneven line with the pen to give the impression of old, worn and weathered stone (Figure 19). The brush pen is perfect for this kind of line work.

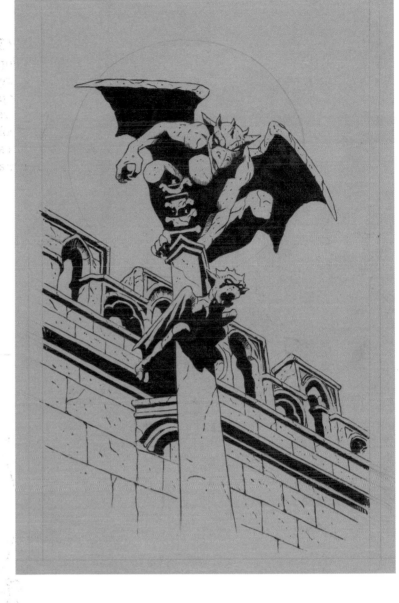

Figure 19

STEP 6

Once the inking is completed it is time to add colour. I used a B26 (Cobalt Blue) Copic marker to colour the sky. When attempting to colour a large area with a marker, always study the drawing first and decide the best position to begin from. Never start in the middle of an area or in a place that will lead you in two different directions. The important thing to remember is to keep the ink flowing until you have covered the required area. I started at the left-hand side of the drawing as it allowed me to put down a continuous flow of ink all the way round to the other side.

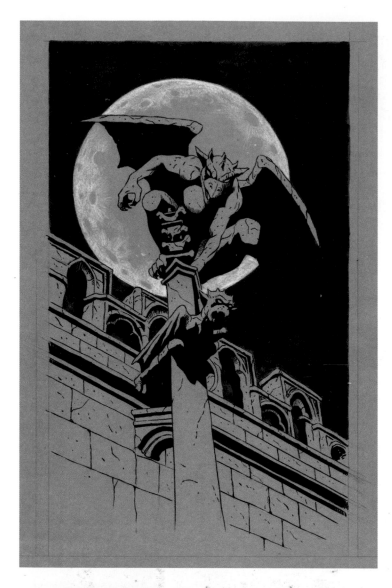

STEP 7

The gargoyle is looking a bit flat against the moon, so use a white pencil (I used a chinagraph pencil, Figure 20), chalk pastel or permanent white gouache to add some detail to the moon. Use a photo (Figure 21) to help you re-create a realistic texture. This will give a sense of depth between the moon and the gargoyle.

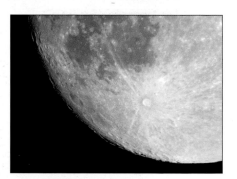

Figure 20

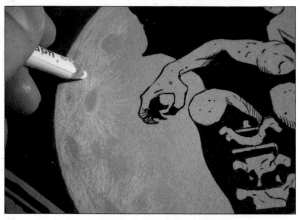

Figure 21

STEP 8

The moon in the background would cast light on the form of the gargoyle. To create these highlights, apply a thin line of gouache to the wings and outer areas of the creature using a No. 2 sable brush.

STEP 9

Finally, add the rain using a Pentel correction pen, which gives a solid white line with one stroke. Alternatively, try gouache and a brush, but I would advise you to practise this technique on some scrap paper before applying it to your final piece of artwork.

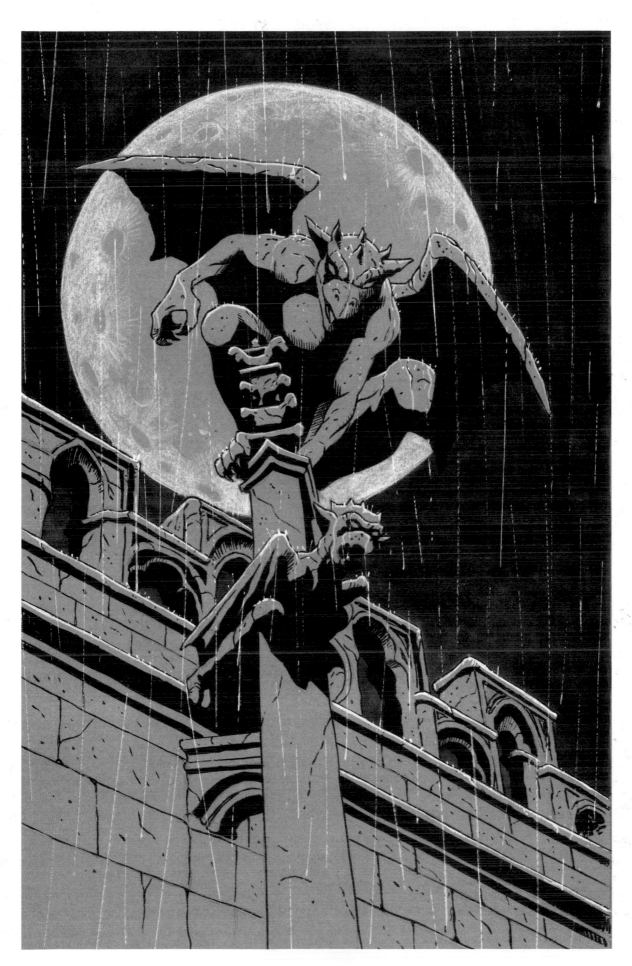

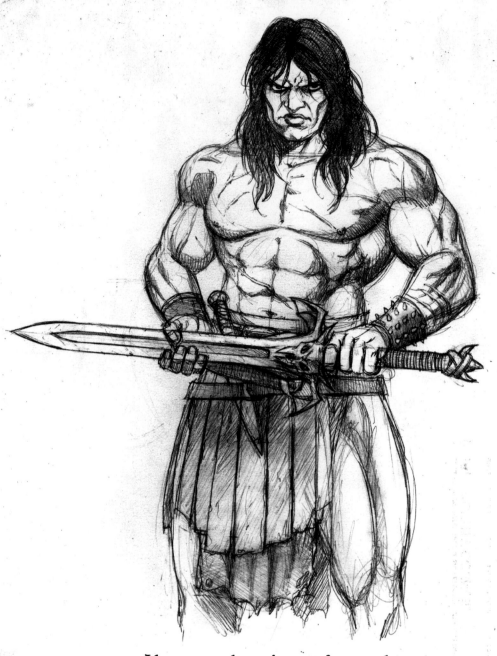

I hope you have learned something
from these exercises and that you have
developed and taken your drawing
skills to the next level, and had some
fun at the same time. The important
thing to remember is that improving
your drawing skills will not happen
overnight – it will take lots of practice.
The more you practise, the more
skilled you will become.